THE ALEX ROSS MARVEL COMICS POSTER BOOK

ABRAMS COMICARTS
NEW YORK

In Memory of Dave Cockrum

A MARVEL MURAL

By Alex Ross

Planning for this series of full-figure portraits goes back to 2018. It wasn't the intention of the commission to have me create multiple pieces, but simply to paint one very large composition. In addition to the other work I was engaged in creating for Marvel Comics, they proposed I do a mural to be installed in their New York offices. The image itself would be an enlargement of a smaller painting, which would be adhered to the long wall in their lobby. The smaller piece of art would still have many challenges in the amount of detail in order to hold up at that larger scale. Instead of conceiving an involved scene with different depths of detail, I counterproposed the concept of having life-size figures of many of Marvel's greatest heroes lined up along the lobby wall.

Going back to my work done for DC Comics, I painted a series of full-body portraits of many of their most well-known characters, which were released as posters starting in the late 1990s, which were blown up to life-size proportions. These pieces were designed, lighting-wise, to fit together however they might be lined up. I held on to this same ambition with Marvel's characters, knowing that there had to be a different attitude in the approach to their heroes. The key thing about painting the figures separately was to allow the mural project to have an additional life as to how the artwork could be utilized. If each body is a separate portrait, then other uses—like the poster book you hold in your hands—would be possible.

Instead of doing one piece of art with overlapping bodies standing in front of one another, I was looking to render each individual figure one by one. The initial sketch I did in preparation for the job to see if Marvel and I were going to be on the same page creatively, used nineteen heroes on an 11" × 17" sheet of paper. I picked only those I thought might make the cut if you were limiting Marvel's characters to their most iconic. To be fair, once you get past the first ten or so that might be universally agreed upon, the choices start to become subjective. The biggest change I received to my layout was that

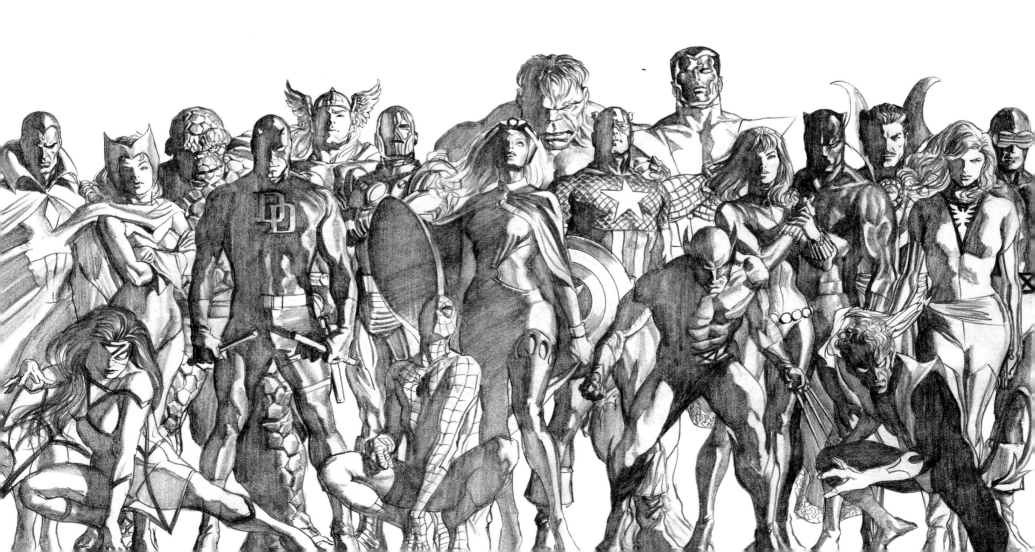

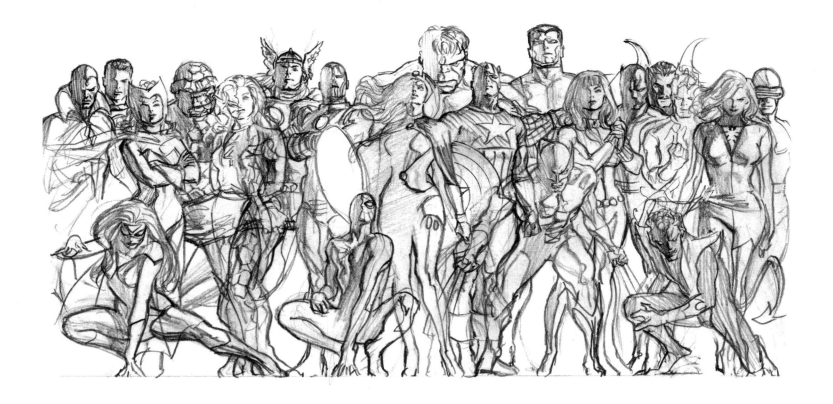

the length of the wall I would be working with was twice the space I had been planning for, and I needed to add many more characters. It was a great relief that Marvel never dictated to me a list of who to include, since I have strong opinions and that could have been a conflict. Fortunately, they fully supported my choices.

THE WHO AND THE WHY

Picking who should be featured in a Marvel mural is something of a history retrospective. There are core characters who define the popularity of the Marvel Universe, like Spider-Man, and heroes who have enjoyed a higher profile in recent years that elevates their often-overlooked importance, like Black Panther. What will likely disappoint many followers of Marvel is who I left out. I avoided heroes who were redesigned or fundamentally restructured in modern usage, since that took away something that was as time-tested as the looks of those I included.

Clearly the designs featured with this lineup favor costumes that mainly defined the super-being in their earliest incarnations. It is perfectly appropriate to go ahead and perceive me as a stodgy old fan who likes things to be the way they were when I was a kid. Opportunities like this commission, showcasing design aesthetics the way I most enjoyed them and how they were when they entered my life, are too good to pass up. What I am clearly doing is preaching about a way to depict the basic identities of these heroes, hoping to make converts to my point of view.

THE HOW

Starting off, I largely settled on poses that fit the spaces they occupied in the group composition. Each character's individual attitudes would naturally inform how they were to be posed. I avoided making any one figure too interactive with the character alongside them so as to limit how they stood (or kneeled) on their own. For example, Spider-Man

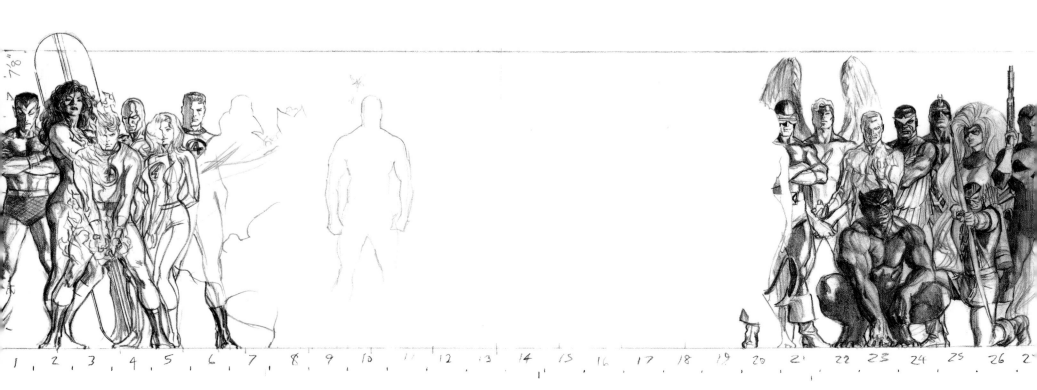

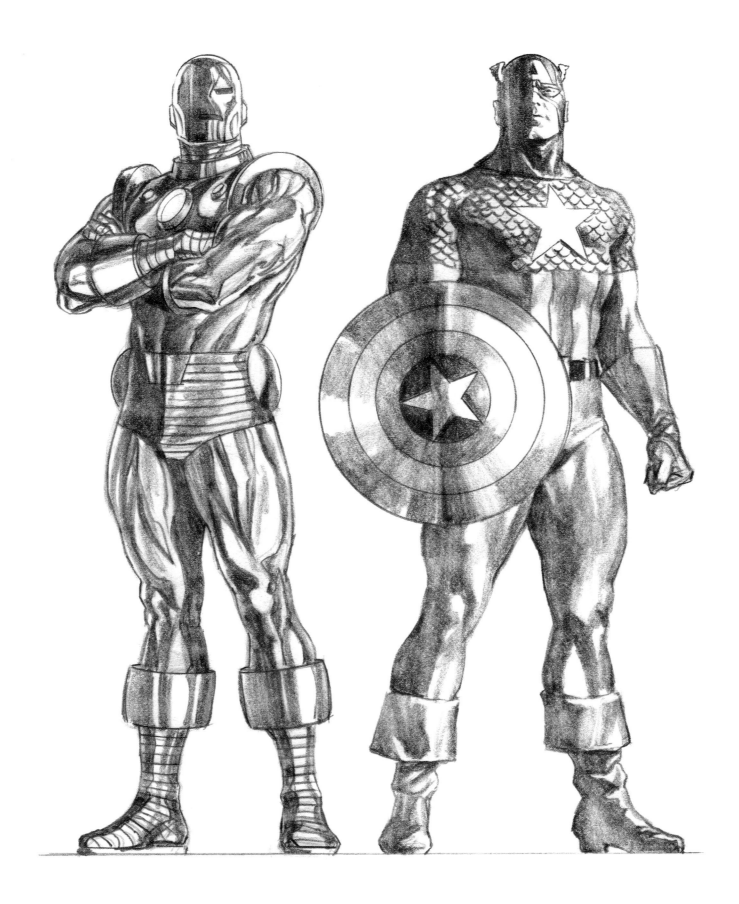

crouching down, no matter his surroundings, is a characteristic pose for him. A greater example of what the individual portraits hold is how I reassessed Falcon while painting him. I finished a full-figure piece of his pose with his arms crossed before I realized I neglected to include his sidekick, Redwing. Given that his bird accompanies him most of the time, almost like an accessory, it seemed necessary to somehow add Redwing into the pose. I envisioned pairings with Captain America and Falcon in other graphic combinations (for example, Cap was designed to fit back-to-back with Iron Man), and I wanted Falcon to be just as majestic as Cap. I started from scratch and unfolded Falcon's arms and expanded his wingspread, adding Redwing perched on his right arm, wings raised. To fit in the

combined group shot, the bird is removed completely from behind Iceman so as not to be blocked, saved ultimately for a place where he is seen in full, like this book.

The paintings were done in gouache/watercolor with both transparent and opaque execution. Often when you see white in my work, it is simply the white of the paper. I decided on a shadow effect with all the figures to create a nearly completely dark side on their right, with a warm light source coming from the left. You will notice that no one is casting shadows upon another, which they would given how close they are standing. Also, the practicality of how the flame of the Human Torch would probably affect everyone near him isn't too realistically considered (although She-Hulk and Silver

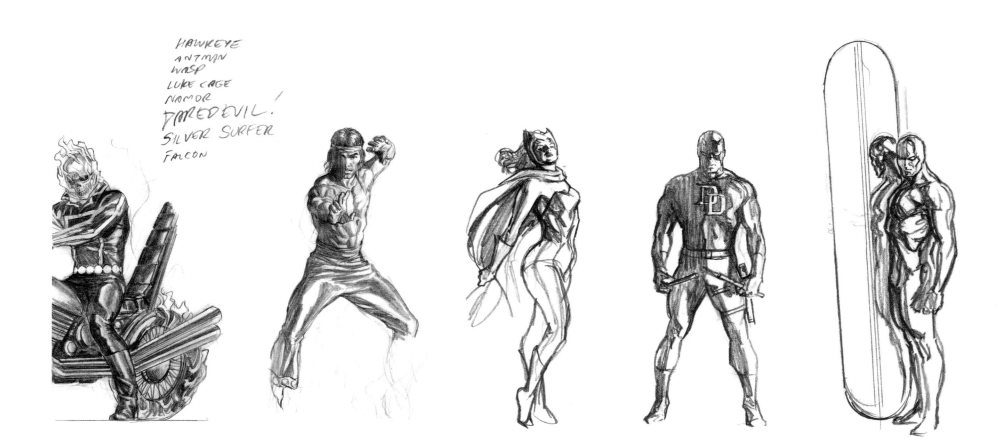

HAWKEYE
ANTMAN
WASP
LUKE CAGE
NAMOR
DAREDEVIL!
SILVER SURFER
FALCON

Surfer could take the heat—and the Torch's sister, Sue, to his left, could be using her invisible force field to shield them—I have no excuse for where Shang Chi's foot ended up).

Most of the figure paintings are only twenty-eight to twenty-nine inches tall, plus the addition of proportionally larger elements like the Silver Surfer's surfboard, Ghost Rider's motorcycle, or Angel's wings. Each piece varied in production time between seven to ten hours, so I was generally able to paint one full figure a day. I did not work on all the pieces in a row, since regular cover commitments and a whole painted comics project interrupted the flow. I started in early 2019, and after putting it aside due to other work distractions, came back to complete it by the fall.

THE WHAT

One of the unusual tools I was able to use in my development of this project was a life-size statue I based my painting on for at least one character. For years, I was in need of a perfect reference model for my depiction of Captain America. I wanted something to look at (and show off) that had the exact detail of costume and huge muscular size that I felt was what the comic art had always indicated. With the help of an existing fiberglass statue, a casting of my life model's head, and the casting and fabrication skills of one of my oldest friends and models, Kenn Kooi (he was once my model for Spider-Man), we set to work creating a custom statue of my vision for Cap. I sculpted a mask and facial details on my

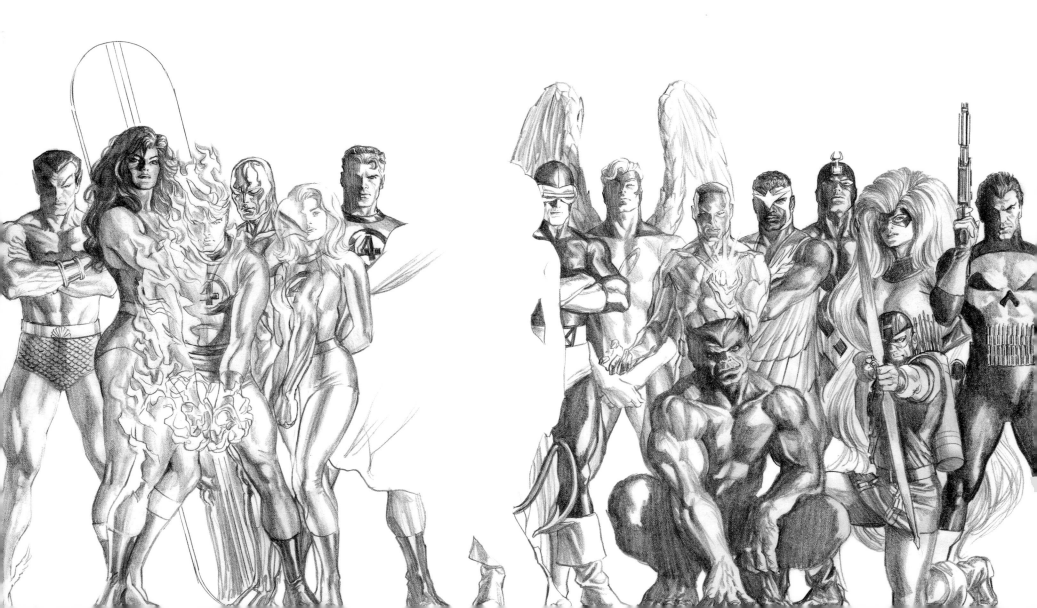

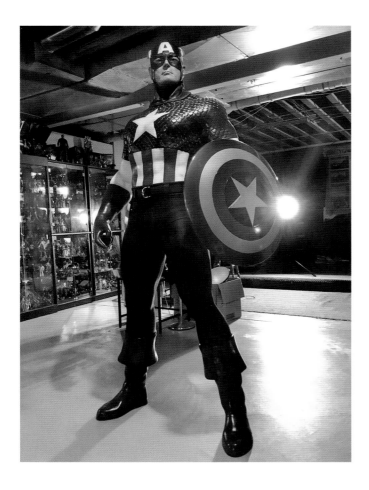

THE ART

Included in this poster book are all thirty-five single-figure portraits, each as their own pinup, ready for framing, with copious notes on the back about the characters and my specific approach to them. There is also a foldout poster of the combined artwork matching the mural image hanging in the Marvel offices.

As one last addition, I wanted to include the major Marvel "shrinking" heroes who were sadly omitted from my lineup. The reason for this was, I reasoned, that since they were only supposed to be small to both get around unseen and sometimes interact with the bugs they were named after, the heroes would be only a half inch in height. Despite many presentations where they looked about the size of a doll, I deferred to their intended shrunk-down proportions. It didn't seem worth putting them in as something no one would see in the mural, and their full-size, enlarged forms wouldn't fulfill the promise of their powers.

So here they are, seen for the first time, still portrayed larger than they would be in action—the Astonishing Ant-Man, the Wasp, and Yellowjacket.

friend Frank Kasy's head cast, put in glass eyes, repainted the whole thing darker colors true to an actual American flag, and made it look like a real guy was standing there.

Using this piece for photo reference grounded the whole project with a key figure to follow and emulate with similar attention to detail. I have, and regularly use, many costume props and sculptures that can elevate my understanding of how these 3D forms translate onto the page. Years ago, I made a chrome-gold Iron Man helmet to study how that surface would appear when I painted it. A good deal of my inspiration is to capture stylistic qualities of how super heroes were originally drawn. Often there are subtle details that get lost over time. The use of painted realism is my way to interpret and keep the forms similar to the way they were when the artists first crafted them.

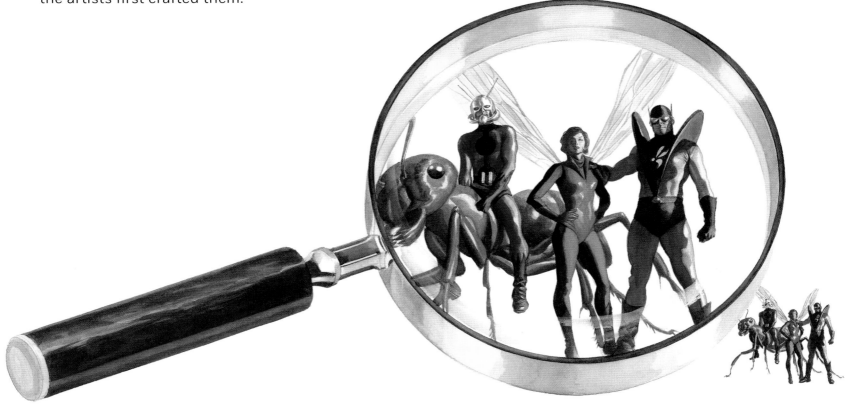

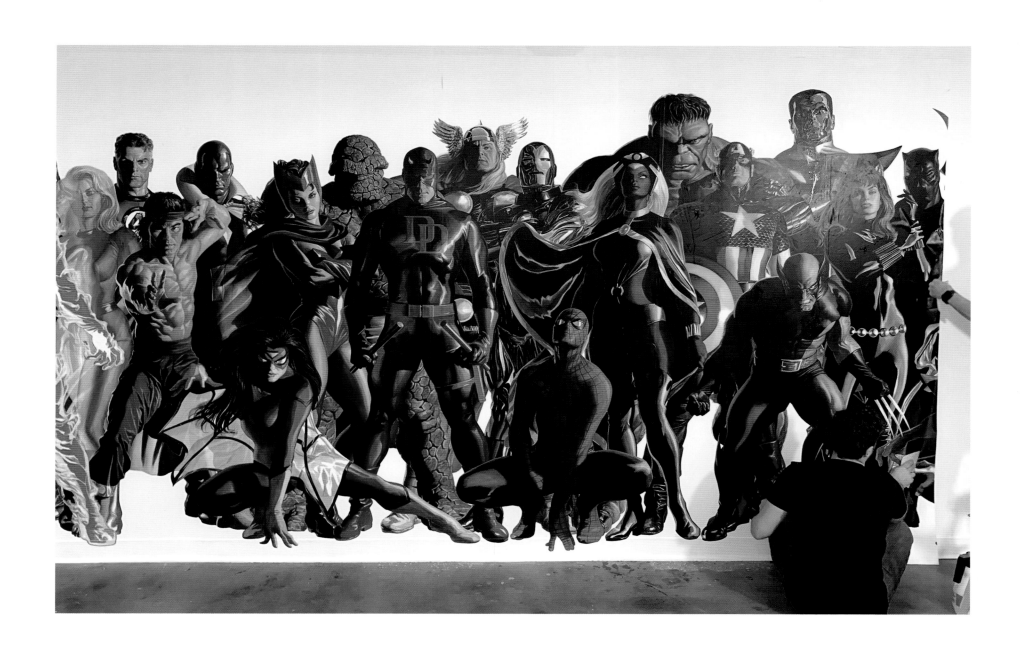

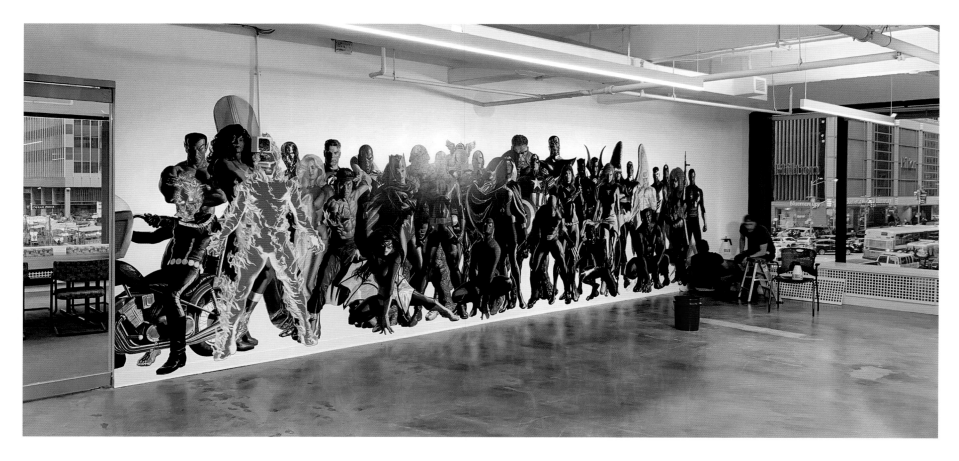

Installation of the mural in Marvel's New York office, February 7, 2020. Photographs by Sal Abbinanti.

THE POSTERS

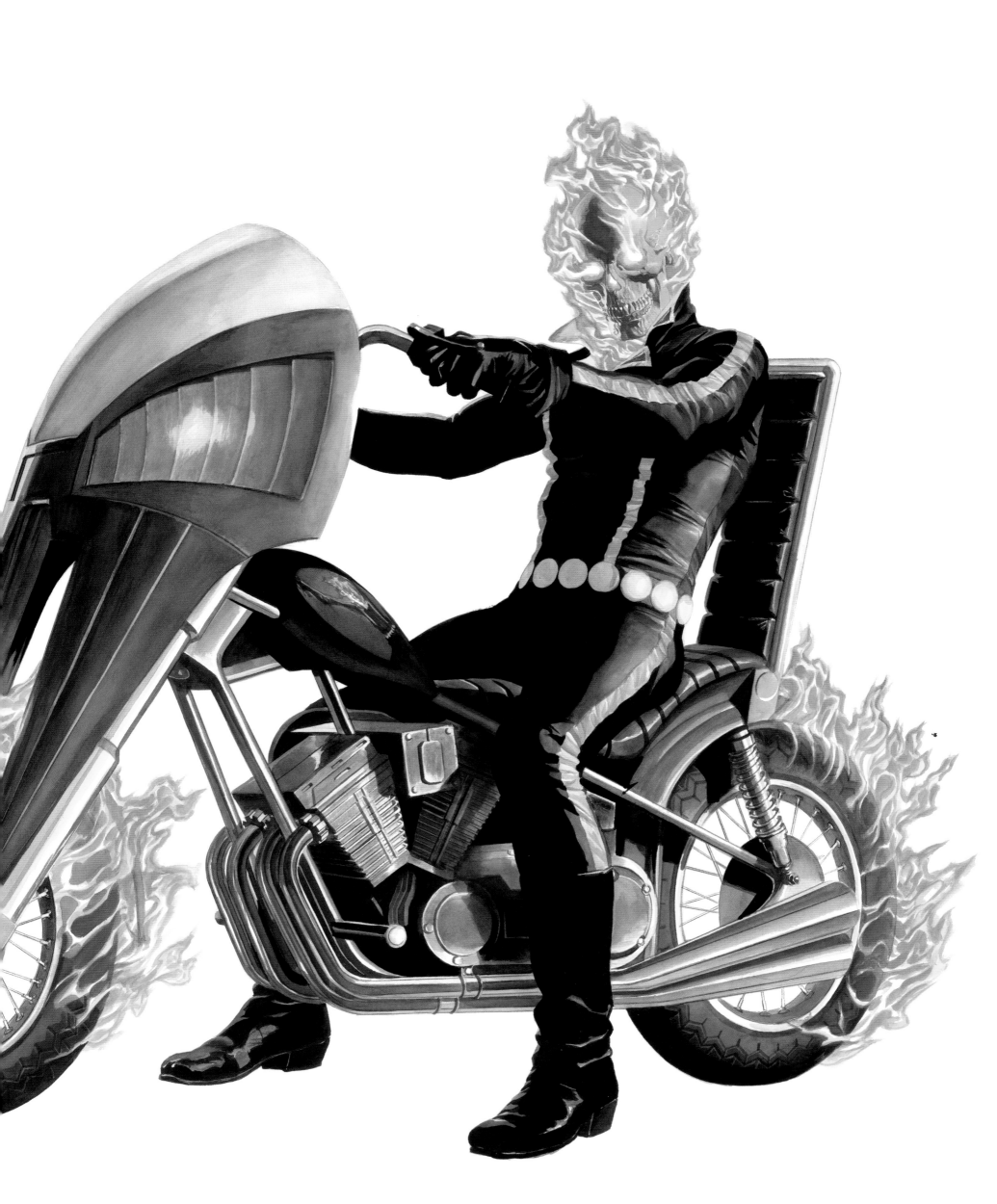

GHOST RIDER

This is one of only a handful of times I have ever illustrated this character. Despite the Ghost Rider's emergence as one of the most recognizable Marvel heroes, he's an icon of comics that I rarely grapple with. To try and present the most timeless version of him, I usually embrace the version I first saw when I was younger, in this case the classic Johnny Blaze stunt-rider persona, with his second motorcycle. The first Ghost Rider-possessed bike had flaming wheels but no other personalized details. The second bike (shown here) was the one to establish a skull face shield that would set the style for all of his motorcycles to follow. Johnny Blaze's clean, formfitting leather clothes made this original version (not counting the white-costumed cowboy Ghost Rider from the fifties) look more like a super hero. Often, his skull head was shown with eyeballs and eyebrow expressions. My intent was to connect the realism of a true skull shape with no attitude enhancement, trusting that the natural details of a skeleton surrounded by flame are ferocious enough. This is a case where the feature film depictions that have come out since the first time I ever painted him have gone far to prove this point, and it is hard for me to compete with the quality of their work.

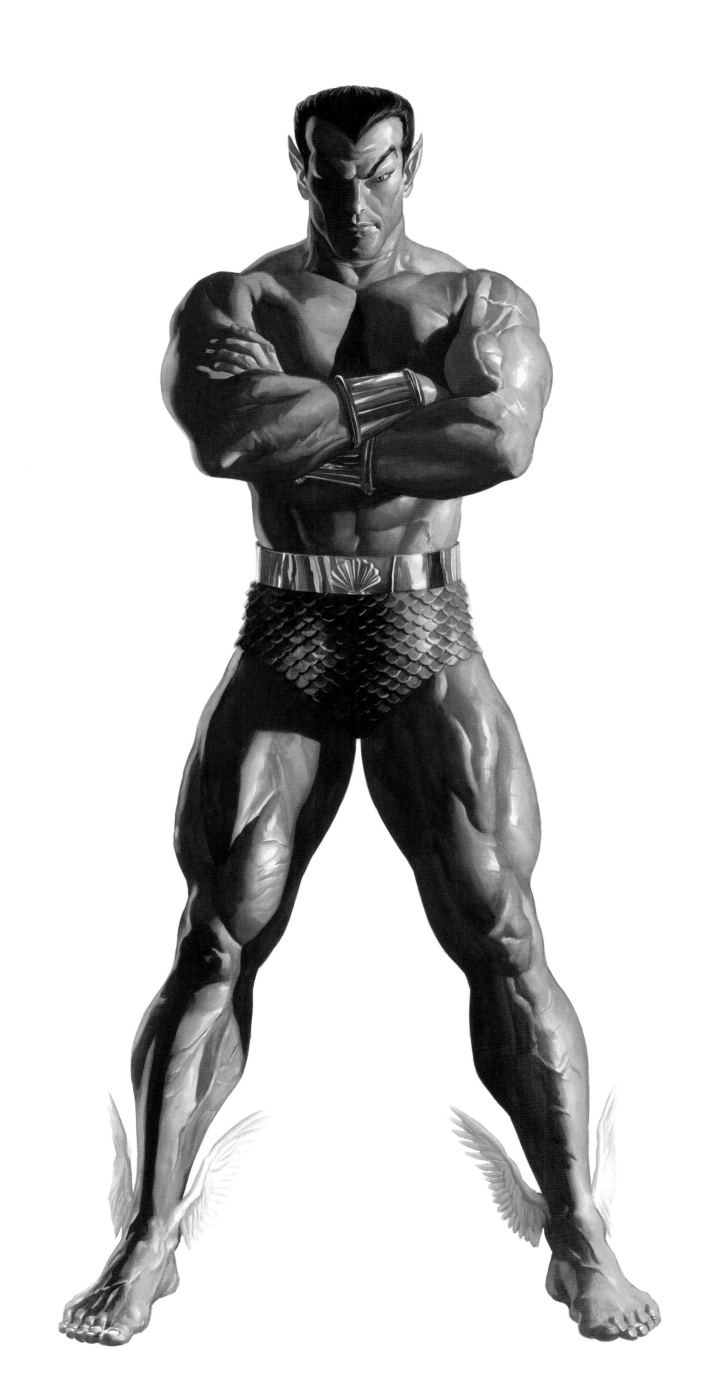

NAMOR, THE SUB-MARINER

Namor is one of my all-time favorite comic-book characters. Created by Bill Everett in 1939, the Sub-Mariner proved to be one of the most original concepts in comics, as both the first half-human ruler of an undersea kingdom, as well as being the first superhuman antihero. You see, Namor walked the line between being humanity's ally and nemesis, and he was often arrogant and unlikable. So, of course, I loved him as a kid. I loved the fact that he could take on the Hulk and he co-headlined a "bad guy" comic book, *Super-Villain Team-Up*, with Doctor Doom. Most of all, I've been drawn to Namor's elfin look, with those big, arched eyebrows, widow's peak hair, and pointed ears. Everything about his face, as Everett defined it, was an angular expression of contempt.

I find it equally interesting, and a credit to the formation of Marvel Comics, that he was one of their original three breakout stars, along with the original Human Torch and Captain America. Namor's heroism was unique, as he was an outsider who judged humankind while joining the fight against greater threats, like in World War II. Namor's long history is marked by wearing mostly nothing—his swim trunks were at first black, then eventually green fish scales. His main appearance never seemed exposed, but instead imposing. His ankle wings are often not understood, but they are a vestige of the influence of Roman gods ("Namor" is "Roman" backward), where this attribute of Mercury is gifted to him. I have always put more of an aspect of myself into it whenever I have drawn the character, and I attempt to translate my own features into the contours established by Everett.

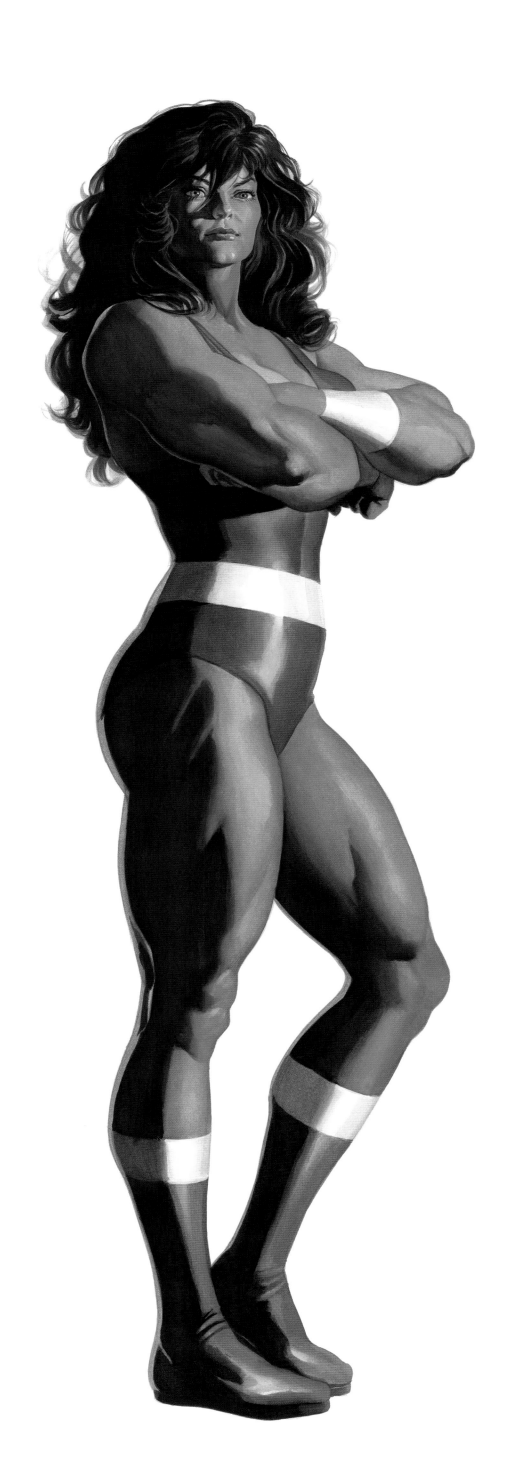

SHE-HULK

Created as a way for Marvel to preserve the name for themselves and prevent anyone else from doing a knockoff of the Incredible Hulk, She-Hulk grew into a unique character in her own right. Mainly because this lawyer super hero did not continue the Dr. Jekyll/Mr. Hyde dichotomy of her cousin, but simply remained herself in spite of giving up her human half-life. She-Hulk's migration from her own comic book to become a team member of both the Avengers and the Fantastic Four made her individual importance grow for readers as she became a more integrated and essential part of Marvel Comics history. For most fans of my generation, the creator whose take most shaped her look and identity was writer/artist John Byrne. In recent years, artists have expanded her size to be similar to that of the Hulk, including all of his distorted proportions. In approaching her most consistent appearance, I embraced the tall, muscular-but-humanoid shape she had for decades, with She-Hulk wearing her purple-and-white uniform.

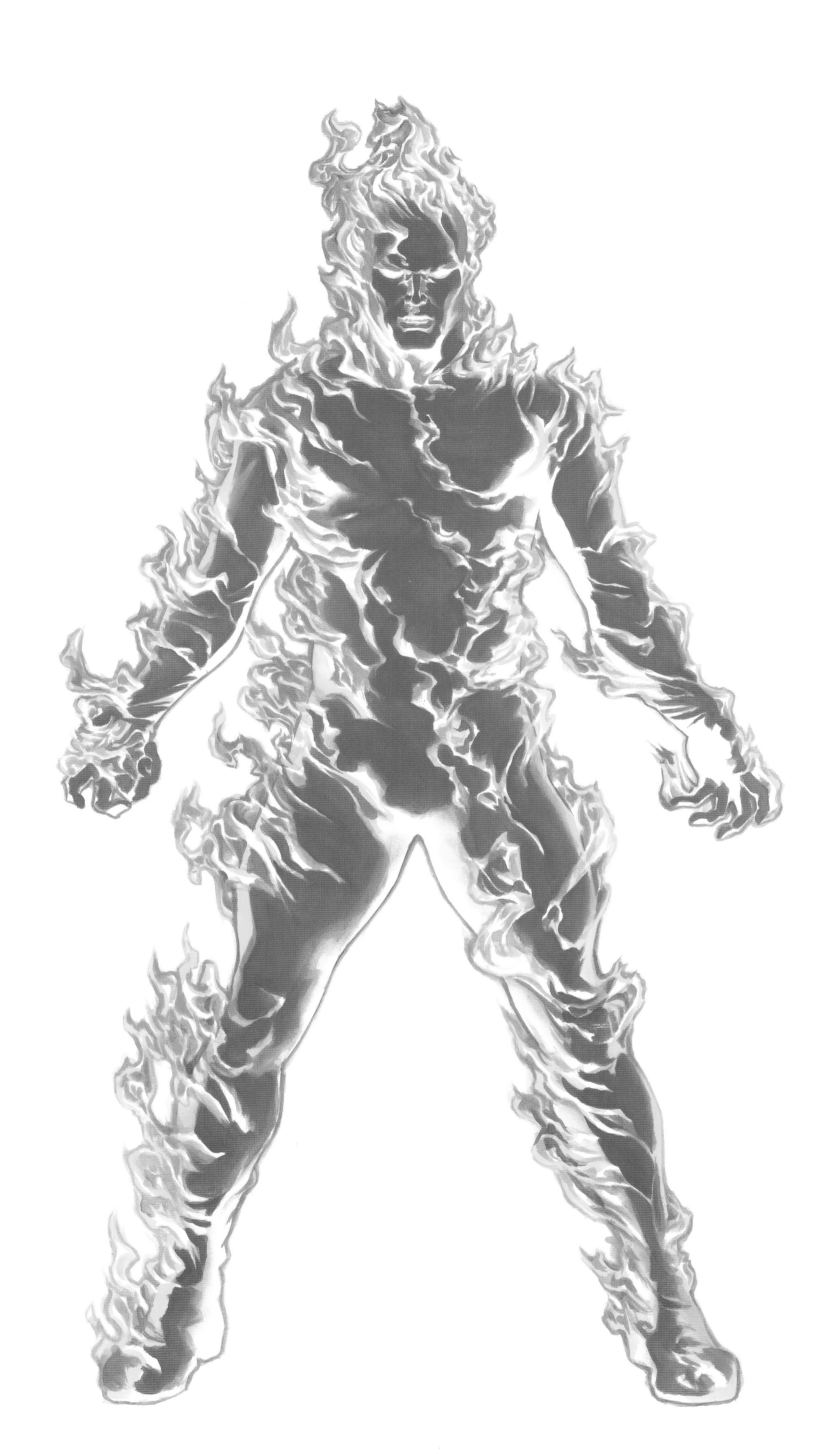

THE HUMAN TORCH

My appreciation for the Human Torch goes two ways: I have a strong bond with the original Carl Burgos-created hero from 1939 who launched the Marvel Comics Universe, as well as for the other, more well-known member of the Fantastic Four. The defining attributes of the first version of an adult lead character (albeit a synthetic man) with a similarly aflame teenaged sidekick, Toro, was reconceived in the form of Johnny Storm, the young hothead of the Fantastic Four team that made its debut in 1961. My initial perception of the character was that of a lead hero, since they tried him out in his own book again when I was a kid. The impetuous youth of Johnny Storm often overshadows the impressive "man of fire" nature of how I always imagined he should be perceived. Starting with *Marvels* in 1993, I have dedicated a good part of my career to spotlighting the original Human Torch as a way to define this earliest of super hero concepts—one that would knock you out if you were to actually see him. In approaching the second Torch and embracing the fact that he is the version most known, I think back to the artist who drew Mr. Storm in the first *Fantastic Four* comic I ever got, Rich Buckler. Buckler often portrayed a husky Human Torch who stood with a wide-legged stance and seemed to be all business when on fire. I've tried to emulate that here, along with the photo-negative effect I've been doing for thirty years in my painted approach to Marvel's first super hero.

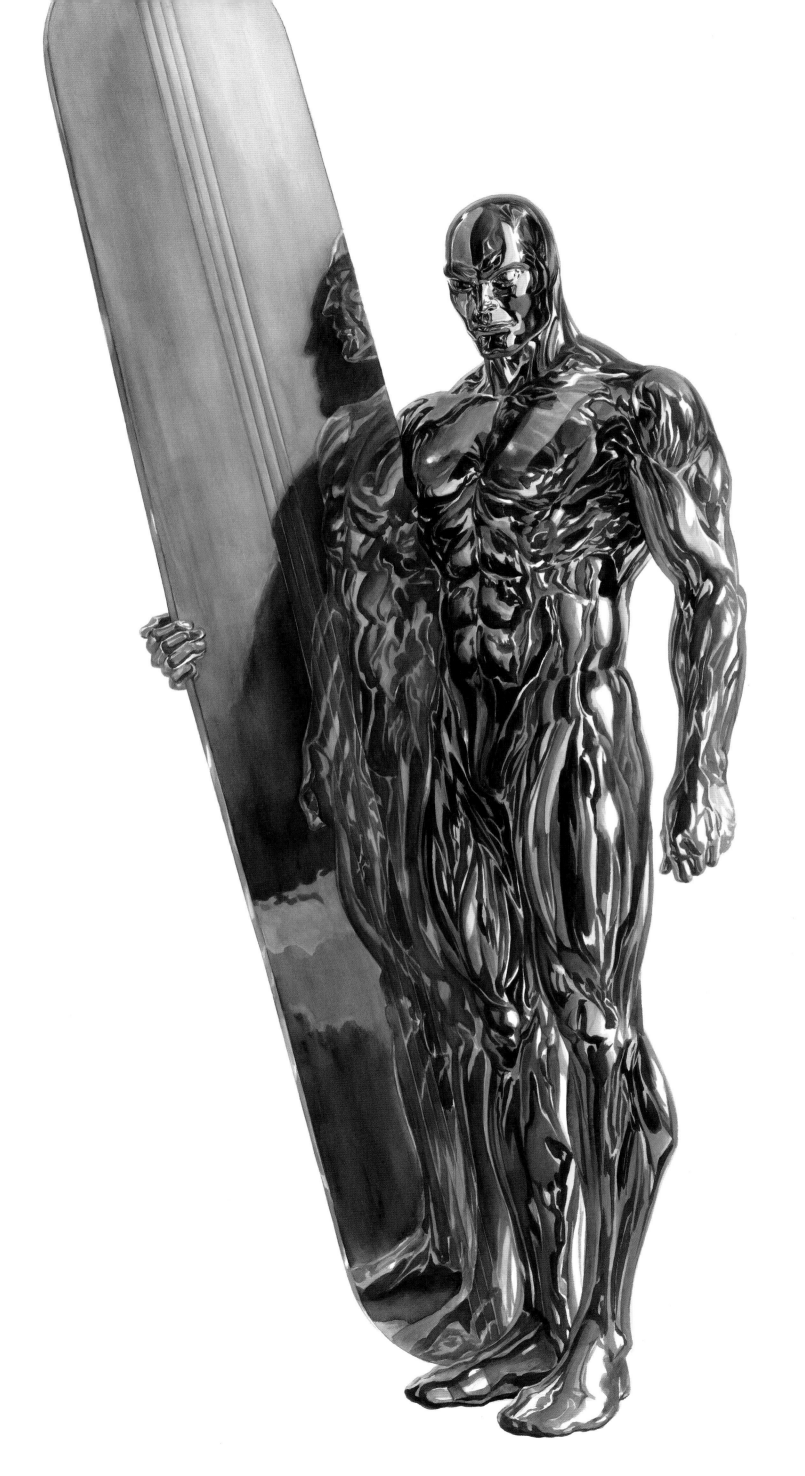

SILVER SURFER

You would think there would be no debate about how to illustrate a character whose very name defines his appearance. As it happened, though, I debated with another artist who worked on the Silver Surfer just how silver one should go. My friend's impression was that he seemed shiny and with a silvery finish, but not necessarily reflective like a mirror. I, on the other hand, have always believed he should be fully chrome. It seemed to me that for the times Jack Kirby drew the character he was actually given full creator credit for, his use of dark accent lines and squiggles, which he employed primarily on metallic objects, meant that Kirby intended for the Silver Surfer to be as reflective as possible. Aiding me in my approach were vacuum-plated toys and figures that I looked at for their mirror reflections. For a hero who never seemed to have changed, the Surfer's two distinct impressions are Jack's original and John Buscema's excellently rendered version. Buscema focused less on the shiny finish than on masterful figure drawing, and he gave the character a beauty unlike most other heroes he illustrated over his long career. Here in my work, I lean closer to Jack Kirby's bulk and facial style as best as I'm able. The time I dedicated to painting every little reflection I found in my reference toy was done in the hopes that it dazzle the viewer into thinking this approach is what is most suited to the character.

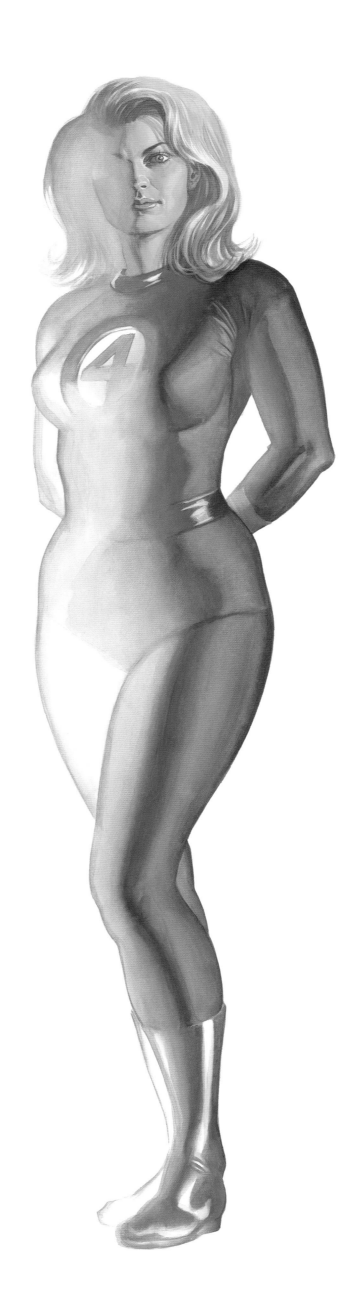

INVISIBLE WOMAN

For most of my youth, I would have identified Susan Storm by the name Invisible Girl, which she held for her first few decades before the fact that she was Marvel's premiere female hero and the first mother super hero began to weigh upon her codename choice. Ms. Storm (eventually Mrs. Storm Richards) was often defined by her humble presence within the team dynamic of the Fantastic Four. Her brother, Johnny Storm (the Human Torch), and their friend Ben Grimm (the Thing), were the visually dynamic and aggressive components that comics sales were based on. Her husband, Reed Richards (Mr. Fantastic), was, along with Sue, a grounding figure to show how there were real, more "normal" people in the mix. She and Reed were the adults in the room. As such, Sue Storm was a figure of beauty, with a mature elegance and a strong jawline. For thirty years, I've aimed to capture the facial distinctiveness that Jack Kirby gave to her in the spirit that she was his prototypical female. Her hairstyle and body attitude are meant to connect to her 1960s origins, as she's not a figure looking to show off or seem prideful. In her relaxed pose and humble bearing, she shows she is removed from all of this foolish super hero posturing.

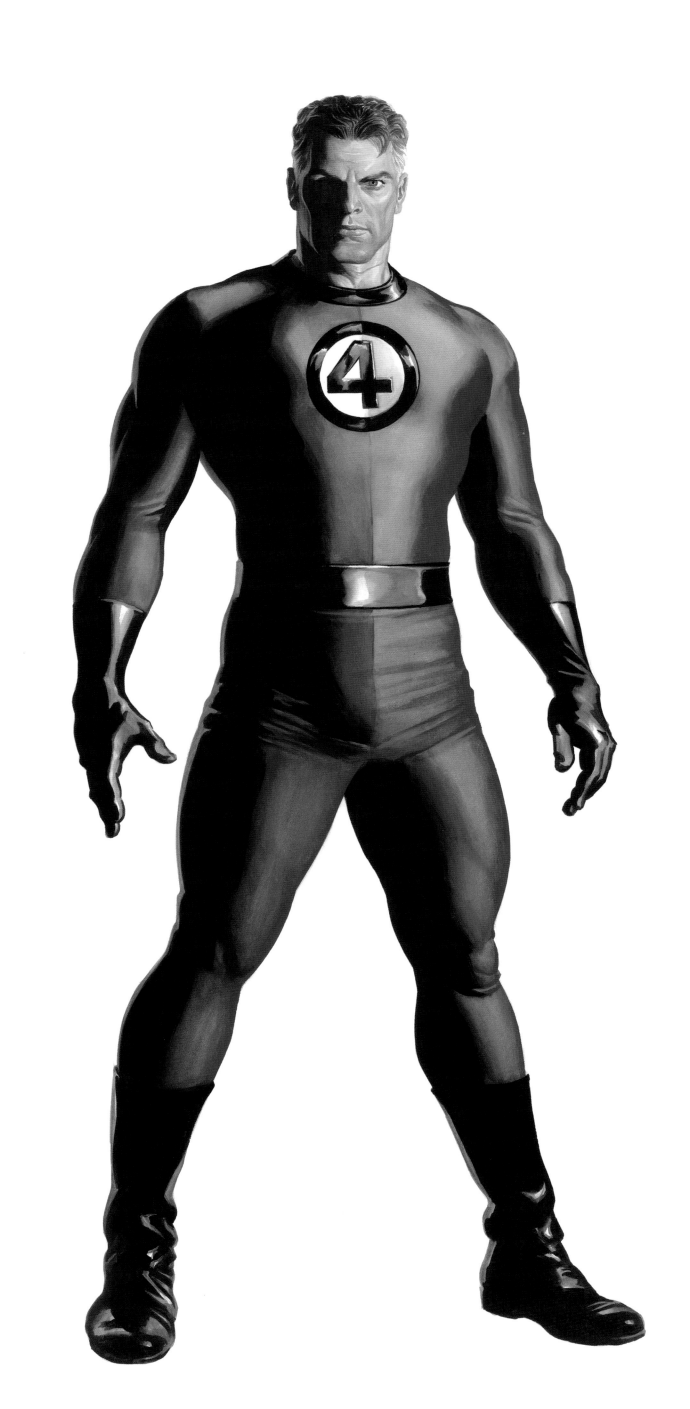

MISTER FANTASTIC

This character, out of all in the Marvel Universe, is my favorite and the one I relate to the most. His appeal is clearly not an immediate aesthetic one, as his costume is designed to be more of a functional work uniform, and his features aren't nearly as intriguing as the romantic rival for his wife's interest, Namor (with his big, dramatic eyebrows). Reed Richards is more of an active engine by which the adventures begin. His scientific creations and constructions are works of art that both created the Fantastic Four and drive the stories they get caught up in. When sixties' culture was opening minds to new points of view and creativity, Reed constructed literal doorways into other dimensions. His genius is what founded the team, funded their activities, and often got them out of trouble. Strangely, his accidental superhuman gift, his stretching powers, was one that never inspired me. He was never a plastic-like, rubbery hero, and it only seemed to serve the idea of his being a man overextending himself. What inspires me about him, and many people I like in real life, is his sense of responsibility. Dr. Richards is the true leader of the Jack Kirby-era of Fantastic Four stories, and, honestly, as a husband, father, and provider, he seemed much more of a metaphor for Kirby himself than the Thing, whom he is most compared to. In Kirby's one-hundred-plus issues, you can see that Reed is the book's primary force, and his intensity of purpose comes across.

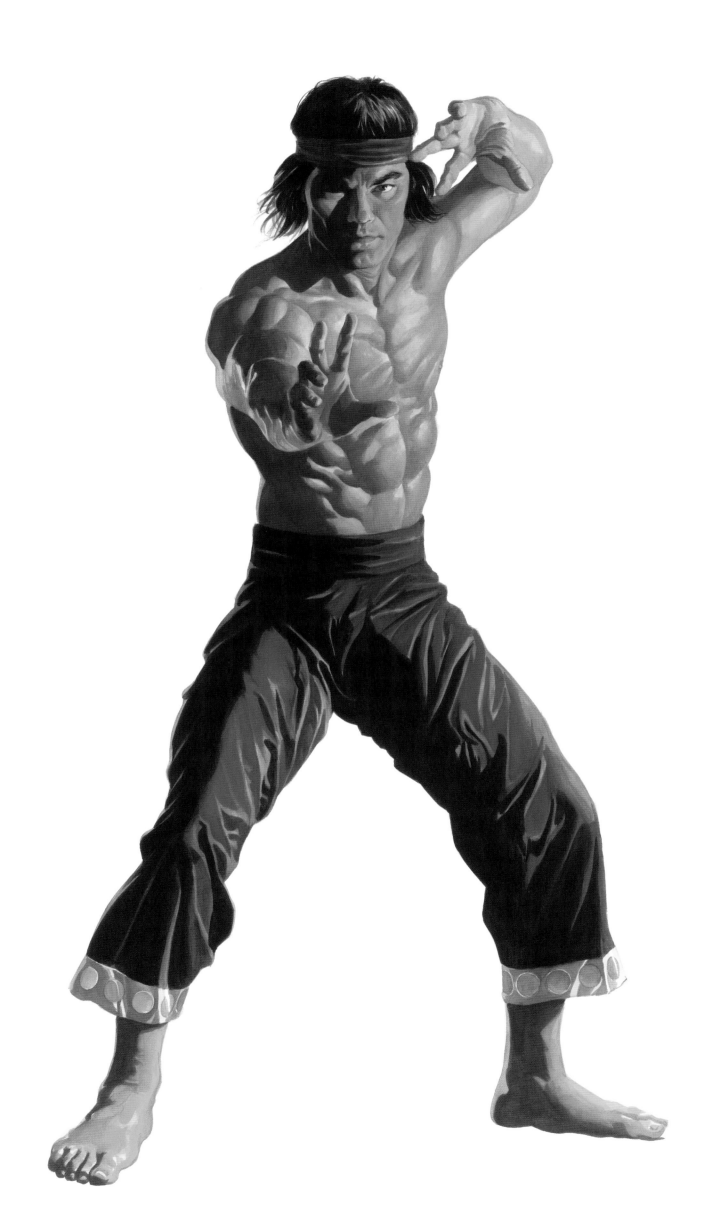

SHANG-CHI

The emerging martial arts movement had no greater representative and success story in comics than Shang-Chi. In part, it may have been simply due to the fact that it was unique to have a lead Asian character answer a newfound interest and maturing of the art form in the 1970s, but it was largely due to the work of exceptional artists who defined their careers while working on this character. Among these many great talents were extraordinary story runs done by comic-book legends: Paul Gulacy, Mike Zeck, and Gene Day. The inventive physicality of illustrating the Chinese martial art of kung fu was key to how engrossing the comics were. Shang-Chi's actions felt like something one might learn from and "master" as he did. The detailed musculature of his tight, lean form made an impression that was unlike other costume-wearing or enhanced comic-book creations.

For my figure pose, I attempted to follow a fighting gesture that I picked out of some of the comics. I admit to no practical martial arts knowledge myself, but I embraced a visual expression that felt right. In the unified mural shot, I must apologize for his right foot's proximity to the Human Torch, which would definitely burn him. Let's imagine the Invisible Woman is creating an invisible force field that shields both her and Shang-Chi from harm.

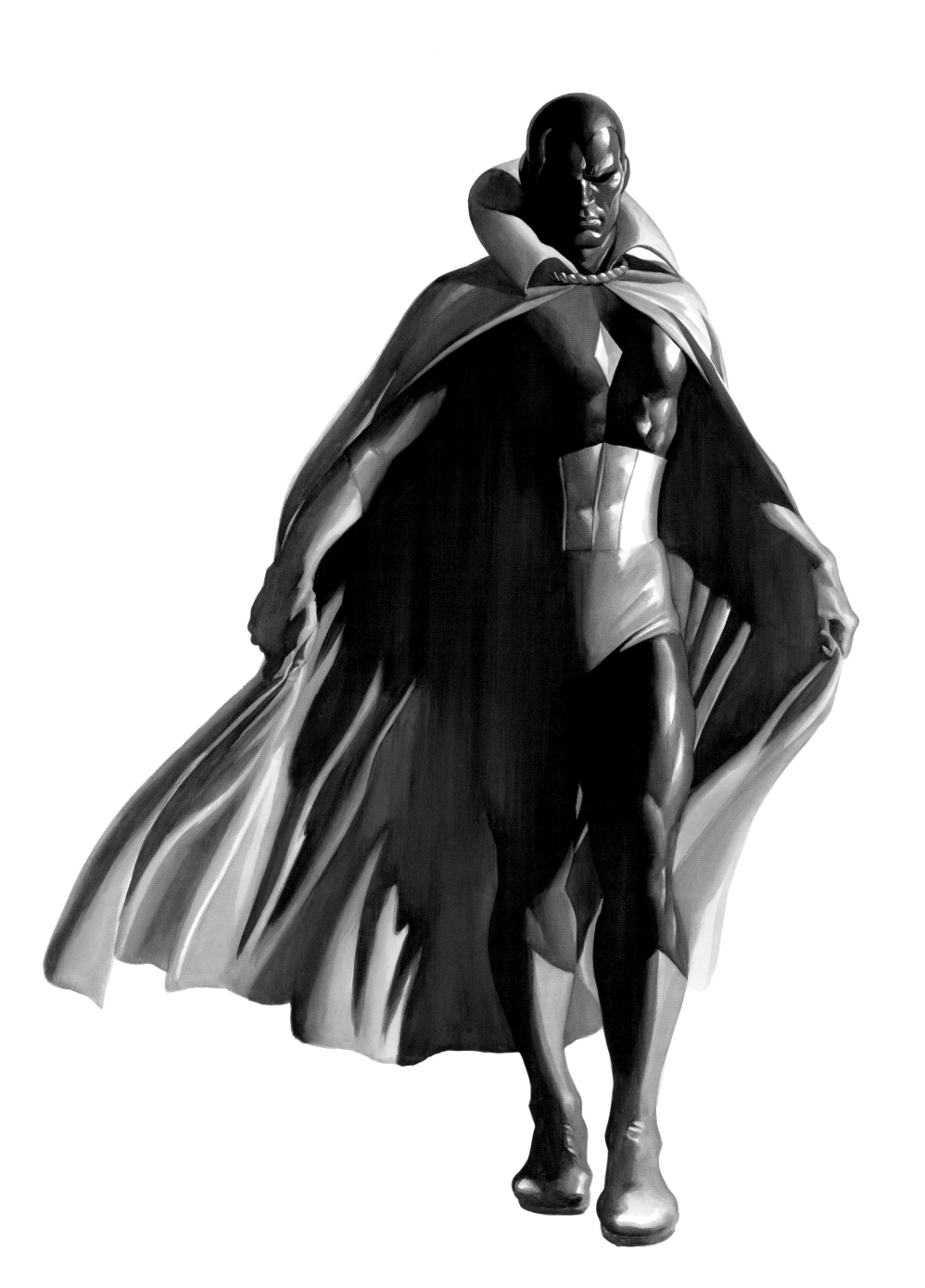

VISION

For some reason the stoic, grim, and mostly bald hero archetypes are my favorites. I feel the strongest connection to heroes like the Vision and others who have that reserved, Spock-like quality to how they present themselves. The Vision was a dazzling character to look at, whose color deviation from the primary red, blue, and yellow-hued leads made him a fitting complement to his fellow Avengers. In Marvel lore, the heroes and villains who wore capes often did so when their powers were so impressive that they had this adornment as a sign of their superiority (Thor is a good example of this). Now, in my mind, the idea of an android or synthetic man—not a robot per se—who can change his density to pass through objects seems like a power fit for a biological unearthly hero. When I learned that the original name-sake he was based on was a forties-era Kirby creation who came from another dimension, it seemed more fitting for me as to what a "Vision" should be. The modern edition was meant to fit a direction from Stan Lee to co-creator Roy Thomas to include an artificial man on the Avengers team. Thomas's collaborator, John Buscema, designed the new Vision with such elegance that his looks commanded respect as well as our empathy. The Vision's darkened eyes added greatly to his mystery. I've illustrated this character many times over the years, but find I need to revisit Buscema's exact feature shapes to try and capture what made him so distinctive. Out of John Buscema's legendary run on the *Avengers* book, this hero may stand as his single greatest graphic contribution.

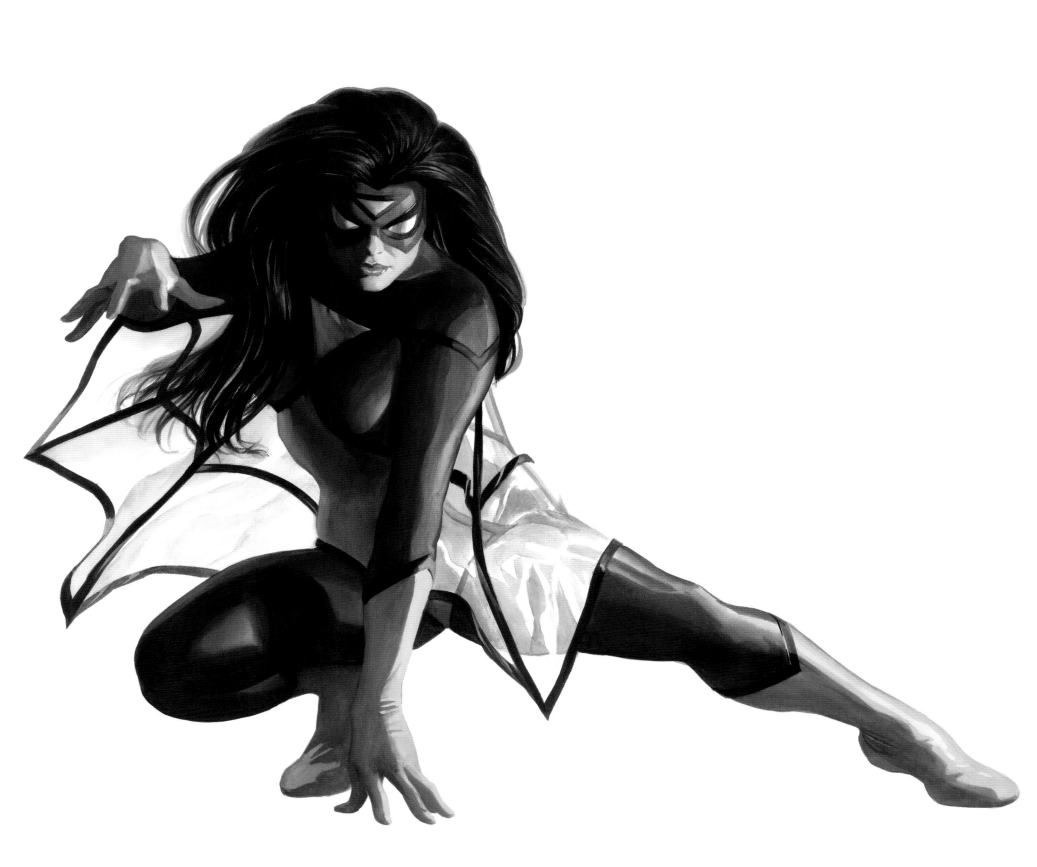

SPIDER-WOMAN

I felt I had identified the full Marvel lineup of core characters when I was eight years old, so Spider-Woman's arrival still sticks in my brain as being one of the "new" heroes. Her creation may have been prodded by the need to preserve the claim to the character name, but she was slowly refined over her inaugural appearances to dazzle readers and become one of the greatest-looking Marvel heroes. She was positioned up front with the most iconic leads for Marvel's merchandising in the late seventies/early eighties, and even launched her own short-lived cartoon show. I fell for her immediately and did not feel a sense of her being derivative of Spider-Man; I just loved that Marvel had such a compelling and much-needed lead female character with her own book. Her history of holding her own series lasted longer than the other super heroines who tried before, but she was still cut short. Although they never killed her off, her name was granted to another woman for a time, and her alter ego of Jessica Drew was still out there somewhere. Fandom has Brian Michael Bendis to thank for pushing for her full revival to the status she had when we were kids. Now her part of Marvel lore and licensing is closer to what she deserves.

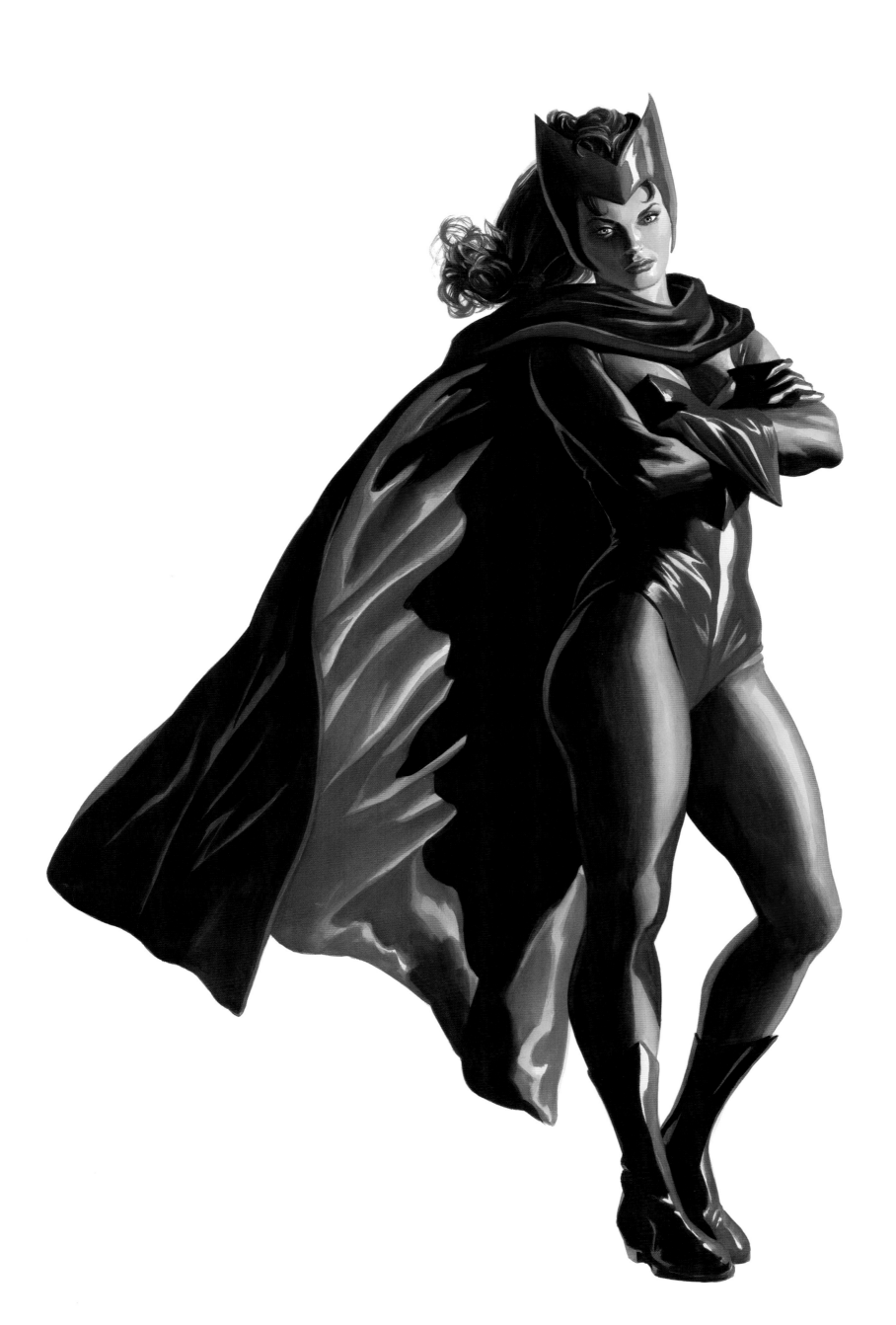

SCARLET WITCH

The most visible of all the important women in the Avengers history is the Scarlet Witch. This is somewhat of a debatable position, because the Wasp was clearly there at the group's start. However, Wasp was often tiny in illustrations and had a propensity to change her look. In contrast, Scarlet Witch kept the same costume for much of the last five decades. An argument could be made for the Black Widow, as she has now been seen on film as a founding Avenger and is a preeminent Marvel hero today, but she wasn't really a regular member of the Avengers team, and she didn't find her signature look for many years. The Scarlet Witch has a distinction she shares with her fellow "second wave" Avengers, Hawkeye and her brother, Quicksilver, who were all considered villains at an earlier point (though mainly through manipulation by other characters) and needed redemption in the public's eyes. Wanda (Scarlet Witch) and Pietro (Quicksilver) added a greater soap-opera angle to the team dynamic, where the brother jealously guarded his sister and would come to disapprove of her union with the "robot" Vision. Their attachment to mutantkind would also add a dimension of world persecution to their makeup. Unlike her brother, Scarlet Witch would come to be a more prevalent and longer-serving member of Marvel's most star-studded super-group. The unique headdress she wears is the clear signature style of her co-creator, Jack Kirby. Whereas her appearance is an impressive styling for a "super hero witch," there was always a humble quality to Wanda's presence. In a romantic pairing that would be one of the most popular in comics history, the Scarlet Witch's acceptance and love for the Vision gives a sense of fulfillment to readers.

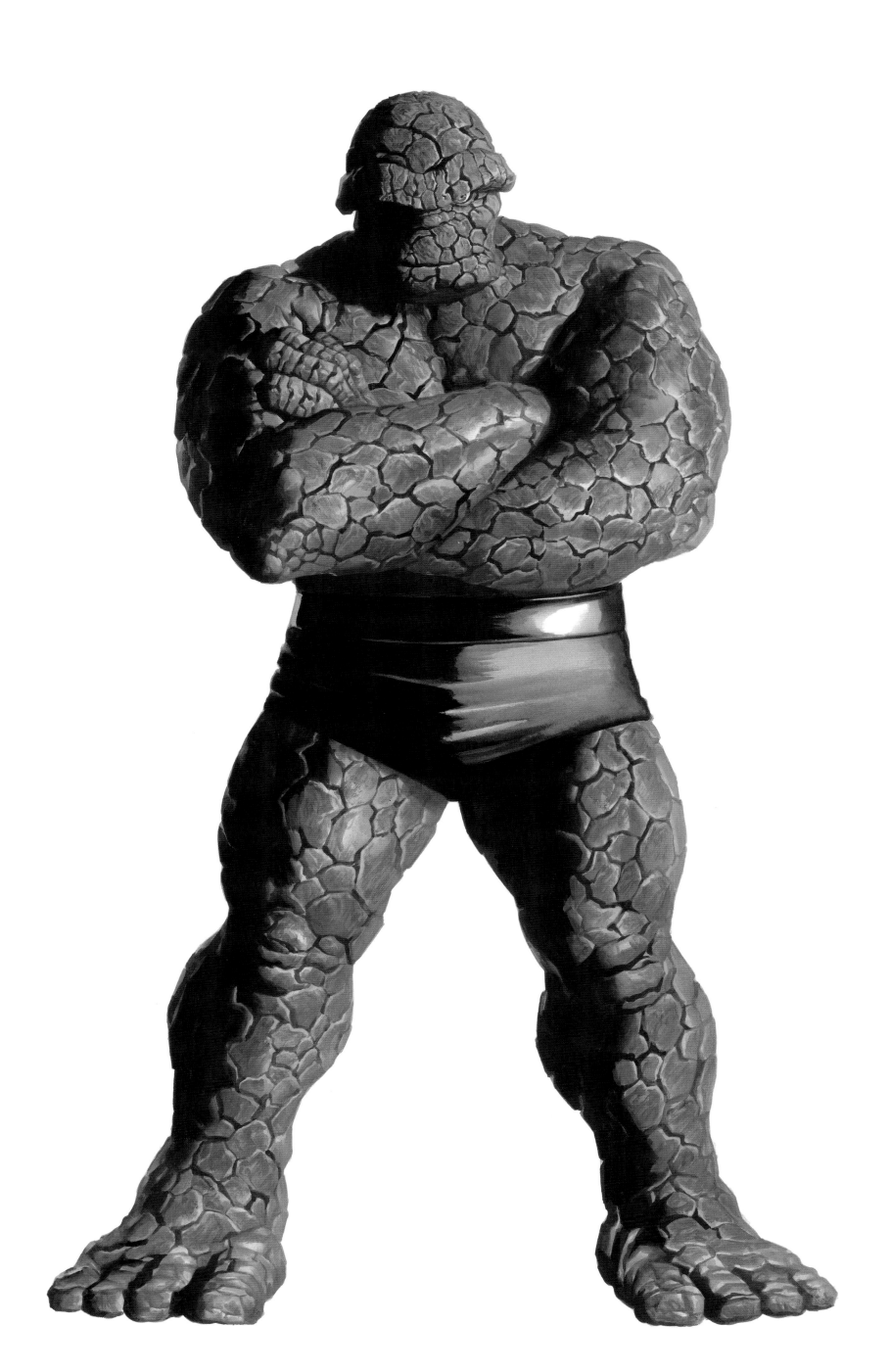

THE THING

The Thing is one of the most beloved personalities in comics. It's hard not to adore the regular-guy "realness" that creators Stan Lee and Jack Kirby imbued him with. The monstrously transformed member of the Fantastic Four is a holdover from the extensive monster comics that Marvel (then Atlas) did in the late fifties/early sixties. His innovation is to keep the relatability of his gruff and grumbly ex-jock archetype with the wounding to his pride that his cosmic-radiation makeover gave him. Ben Grimm (the Thing) made the "World's Greatest Comic Magazine" that much greater, and a compelling read that really stuck with people. The Thing's rocky exterior evolved from a less-appealing lumpy shape to a more-defined cracked earth that was most consistently embellished with the beloved inks of Joe Sinnott. His final execution of the character would come to be the signature way the Thing was identifiable through multiple artists' hands for a decade and a half. With my personal engagement in trying to paint this hero, I've worked with a friend's hand-sculpted foam Halloween mask and gloves, as well as a fully rendered life-size bust that artist Lou Cella made twenty years ago, which perfectly captured the classic Kirby/Sinnott look in all its stony glory.

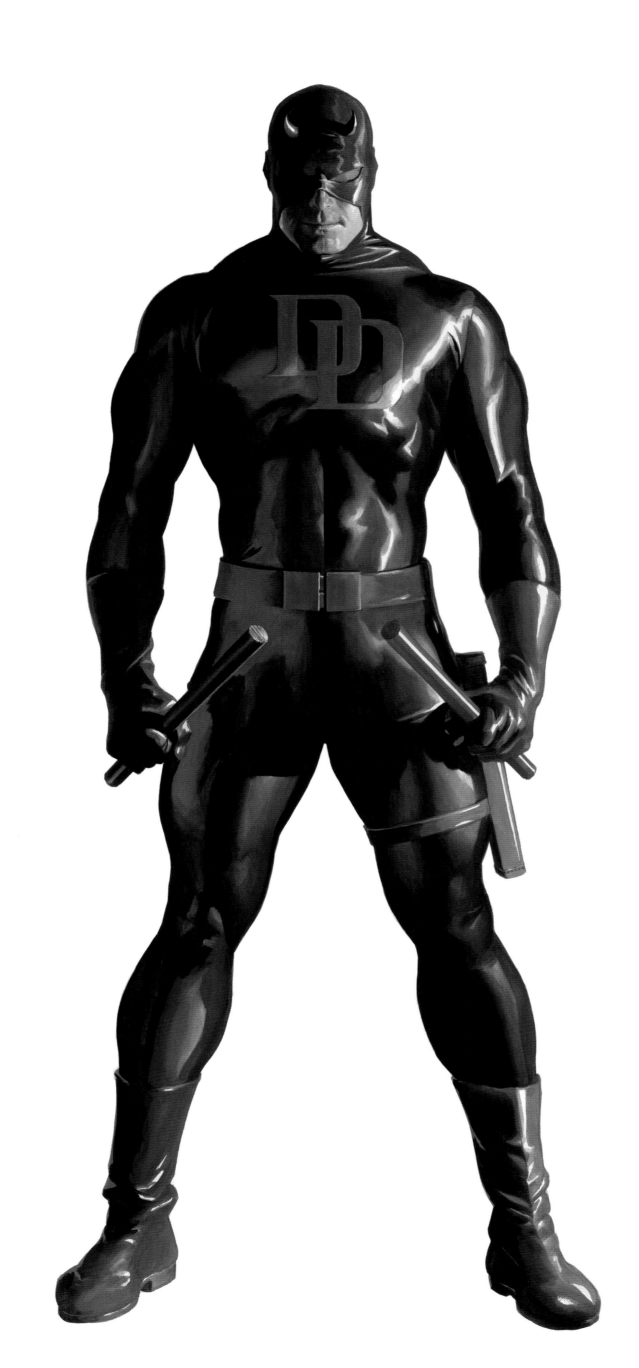

DAREDEVIL

Some of the best comics written or drawn have been about this hero. Having a unique design evolution from three comics legends—Jack Kirby and Bill Everett, with Wally Wood ultimately revising and defining the Daredevil we know today—his storytellers have often been some of the best the art form has known. Although Daredevil was blind, his other enhanced senses provided him skills he could develop and gave him one of the most engaging points of view in comics, cinema, and television. The creative challenge of dramatizing his day job as a lawyer balanced with his super hero side inspired writing that set a very high bar for others who followed. Intellectually, Matt Murdock/Daredevil has consistently been one of the easiest characters for readers to identify with as well. Artistically, I feel the look that most defines him comes from Gene Colan. Colan's work spans one of Daredevil's longest artist runs, from the sixties through the seventies, and he always gave a bigger, impressive frame to the hero. This idealized, archetypal super hero bulk made him seem like Marvel's everyman, wearing a costume to fit that mold. A weird challenge when depicting Daredevil has always been his red-black clothing. Whereas Wally Wood used charismatically placed shadows to accentuate his "devil" moodiness, I've mostly gone after a velvet finish that creates large, dark impressions with bright red highlighting. But I have no answers for what he would actually wear if he were real.

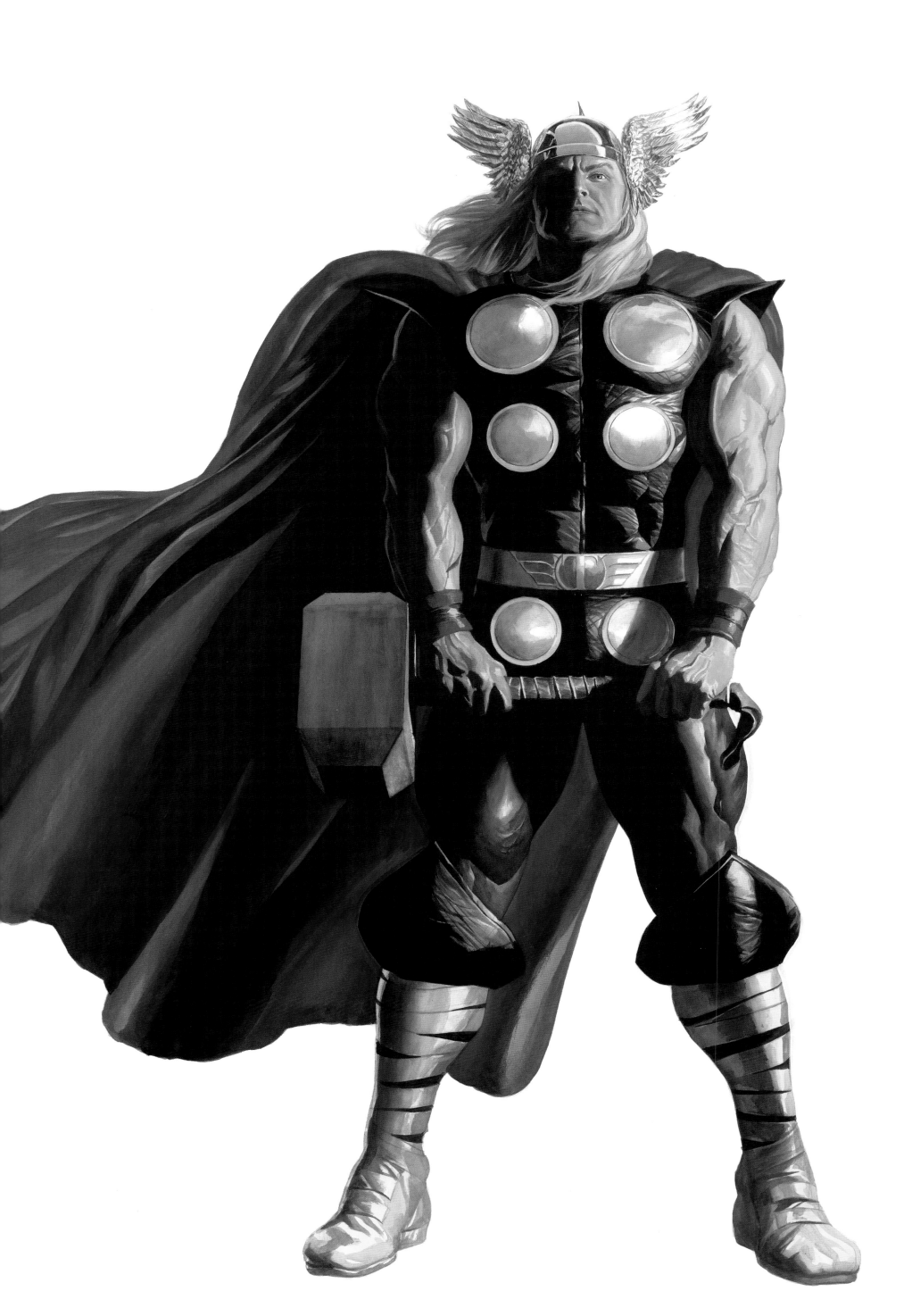

THOR

I've often had trouble as to how to perceive Thor. When I learned as a child about the classic mythological description of him with red hair, a beard, and an iron glove, I wondered why that information didn't match the Marvel Comics interpretation. As it turned out, Jack Kirby had illustrated various stories with the original god-figure throughout his career before, and much of that looked like the established legend. With Marvel's burgeoning lineup, Kirby and Stan Lee may have decided on a new approach that felt like a sort of super hero Viking, cleaned up for the sixties' youth they hoped to entice with his adventures. Whatever the logic, it worked. The abstract discs that represented ancient armor on Thor became something of a brand insignia. His leg straps read less as leather crisscrossing as they held up his boots/sandals, but more as textured markings. The winged helmet and cape were not authentically Viking per se, but they made his divinity that much more indisputable. Thor was the regal superhuman from a fantastic land far away. As a kid, I often thought he needed a grit added to him, which has since been conveyed by the many artists who have portrayed him with a beard. As I look back on Kirby's historic establishing run on Thor's book, I see more clearly now what the character embodied. Thor was the flamboyant cipher of our greatest noble qualities made flesh. He often was our guide into the established legends of Norse, Greek, Roman, or other mythology, as well as the new imaginations of worlds, enemies, and creatures that Kirby could conjure from his pen. Thor was our gateway to all of that. His own definition was meant to be less of a distraction to that goal. Arguably, Thor wasn't necessarily meant to be cool, because he was greater than that—he was pure. He was pure intentions and grace-given form, used as a storytelling ferryman, transporting us to somewhere new and exciting. That said, I came to love his graphic look and the subtleties found within him. For one, Thor is big—*really big*—and both more muscular and taller than the super hero leads he usually teamed with, including Captain America and Iron Man. Thor's features were distinctly handsome and attractive, never warrior-like. If portrayed the way Kirby hinted at, I believe you get a vibrantly hued, chrome-winged, helmet-adorned titanic figure that you wouldn't be able to take your eyes off of.

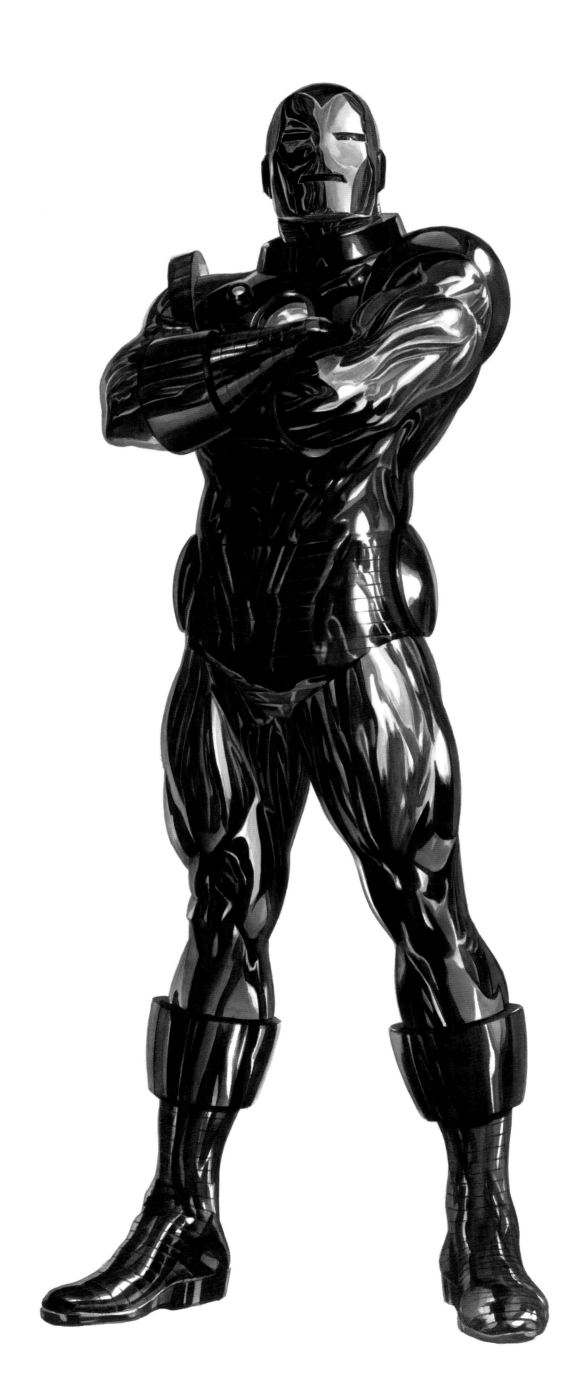

IRON MAN

It's nice to see a world where one of your favorite characters becomes as beloved to others as they were to you. Iron Man was always in the top tier of most important Marvel heroes, as far as I was concerned, and even in the top four. For comics readers who had followed him for a long time, we knew how important he was to Marvel history, and how inherently cool he was. Iron Man was one of my favorite characters to read about and to draw. I loved how the simple, graphic three lines of his helmet's eyes and mouth gave his face a stoic impression. The classic armor for Tony Stark/Iron Man is actually his third or fourth. After two versions of his larger, Kirby-initiated "big can" armor, Steve Ditko stepped in to design a sleeker, formfitting armored costume that made him look more like a traditional super hero. This was the red-and-gold combination that would inspire his updates. Ditko's first details were refined with a couple of tweaks, leading to the suit Stark would wear for the next twenty years or so. Given that this was my first introduction to Iron Man (aside from the fact that there was a short-lived nosepiece added), and it's the look that would span the most notable points in the character's history, I have always tried to reinforce its importance. My main approach is to embellish the armor's contours with a full mirror-like chrome finish. I based my work on a prop helmet I sculpted that was chrome-plated in red and gold to use for jobs just like this one. The ink "squiggles" that artists like Kirby and Bob Layton used to indicate a reflective surface on Iron Man inspired this approach.

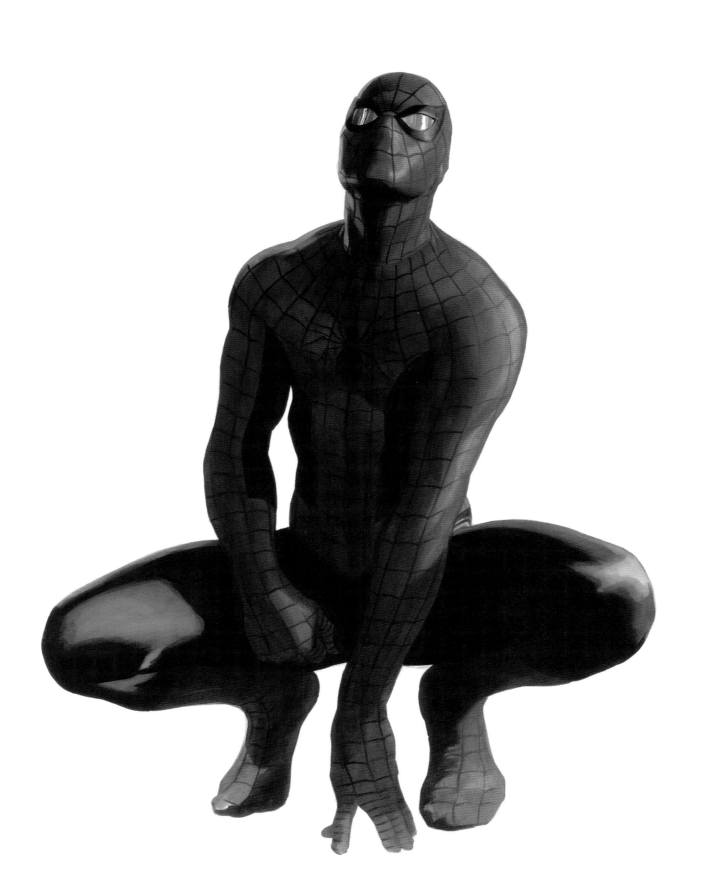

SPIDER-MAN

What can I say about the hero who got me into comics and sparked the focus for my art and life? Probably too much. Spider-Man's first impression on me was as a real person wearing a costume, thanks to Danny Seagren playing him on the *Electric Company* TV show. It has always been, to my mind, how to visualize what Spider-Man looked like in reality. Mostly, I just wanted to be him, or at least dress like him. The costume that Steve Ditko crafted was perfect in its effectiveness to survive the ages. The mask became a face, with carefully placed webs that indicated the nose and mouth as lines in a natural design pattern. If there is a pair of eyes more attractive in comics, I can't think of them. The later interpretation that John Romita Sr. created carried over into my childhood and inspired countless artists like me. As the look of Marvel's upstart super hero line refined, Romita's style became the defining look. I feel that Romita's Spider-Man is the best-looking character in comics history, and his work is what I try to emulate. I've constructed reference props to draw from, including a hand-sewn mask I painted lines on, as well as a life-size sculpture I collaborated on with artist Mike Hill, which I often use as my basis for photography. More recently, I have tried to imitate the darker red paint color that Mike Hill did on the bust, which is meant to indicate a well-worn look for the costume. If he is swinging in the polluted air of a congested major city, he's probably not going to look that clean for very long.

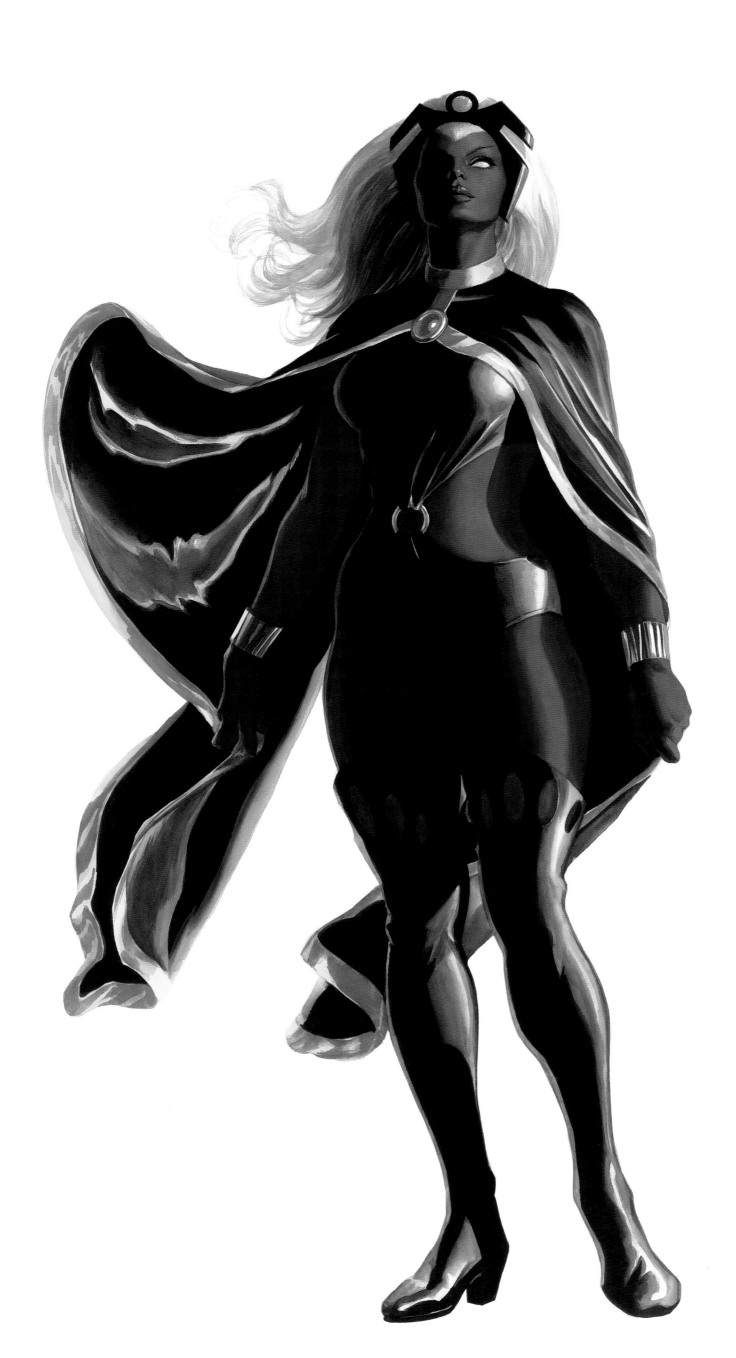

STORM

Dave Cockrum's design for Storm is quite likely the most recognizable African super hero design. Unlike the Black Panther, who is entirely covered, Storm is clearly identifiable as a Black person. She was also more visible to millions of people as part of the tremendously impactful X-Men group (that Dave Cockrum redesigned) who have been consistently popular for the past forty years. Part of her unique look is her white hair—a sign of her mutant powers—which contrasts strikingly with her skin tone, a balance exploited in a great many designs for super heroes of color. Also distinctive to Cockrum's rendition of Storm is a certain cat-like shape to her facial features, which is a holdover from his original designs that planned for her to be a half-human, half-feline character. The classic Storm costume is what I delight in drawing every chance I get to depict her. The midriff joining of her form-fitting top and bottom creates an hourglass shape, with her thigh-high boots and short cape completing the elegant look. Storm always seemed like stylized royalty in the super hero genre. Her ascension to becoming a team leader was a personal development that fulfilled greater potential. The construction of this mural group shot had her positioned at its center from the start. I wanted her placement to draw attention to Marvel's long history of greater representation for all people in the ranks of their heroes.

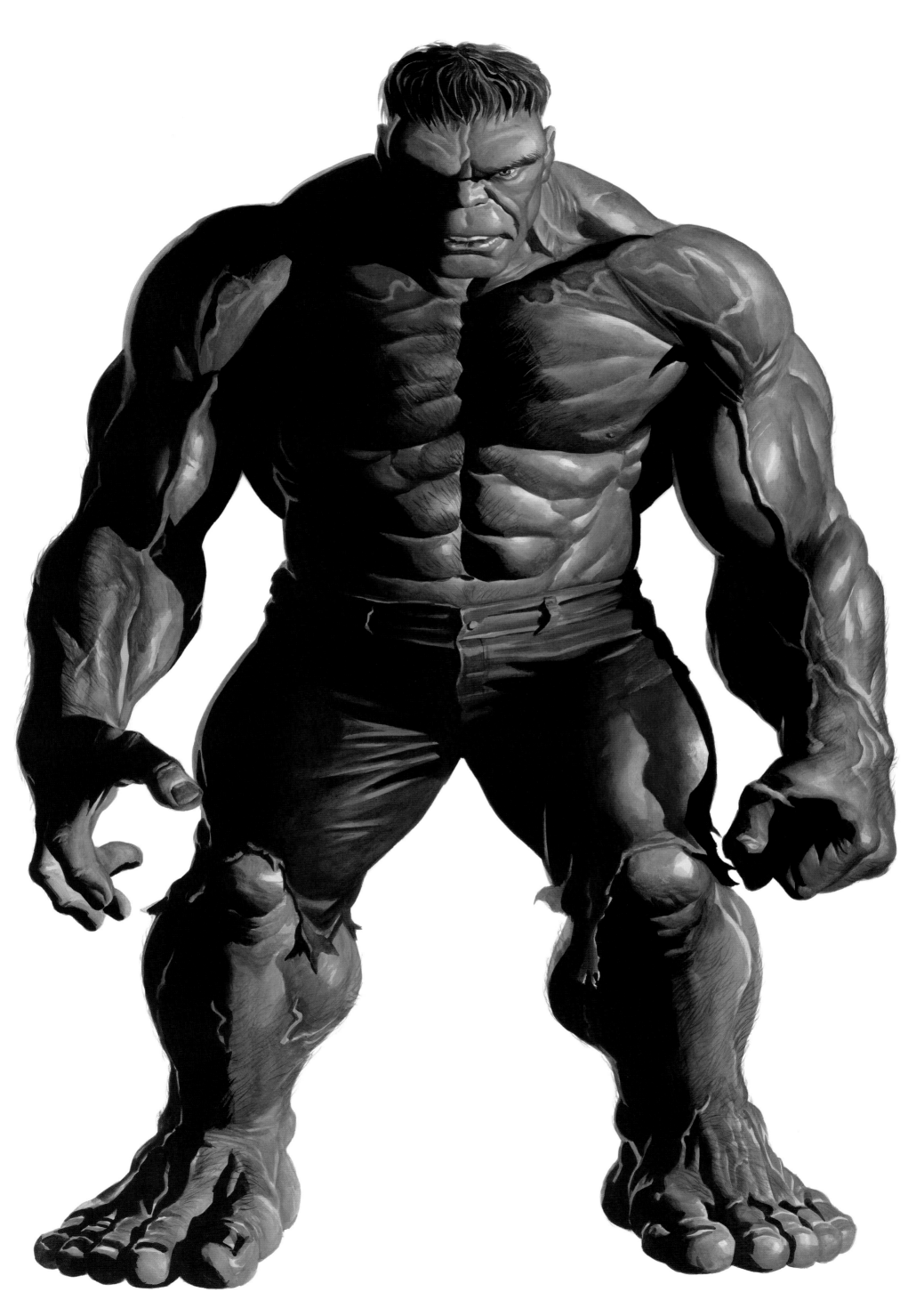

HULK

The signature muscle-bound, mutated body shape that Jack Kirby gave to characters is embodied by his design for the Hulk. The actual proportions of his figures when done this way look more like infants with muscular definition. The way of creating a bulky frame with enlarged fists and feet and shortened limbs became a popular staple in comics, where the strongest adversaries were often depicted in this manner. The "good" monsters like the Hulk and the Thing made this style fit for heroic identification. In my years of drawing the Hulk, I've attempted to do the enlarged brow and Frankenstein-monster-like features that Kirby gave him during his time drawing the character. The hairline appearing like a disheveled mop wig sitting on top of a sloped and flat cranium exaggerated the effect of the Hulk having expanded outward from his Bruce Banner size without the placement of his features lining up right. Given that the Hulk was first colored gray, then switched to green, I have always felt that the appearance of his skin color should be subdued and not the vibrant chartreuse green it sometimes comes across as. In developing my approach over time, I have directed others in sculpting full-size Hulk busts, but I eventually sculpted my own, basing it on the early Kirby comics. I use this as a photography model to study lighting and form for my paintings.

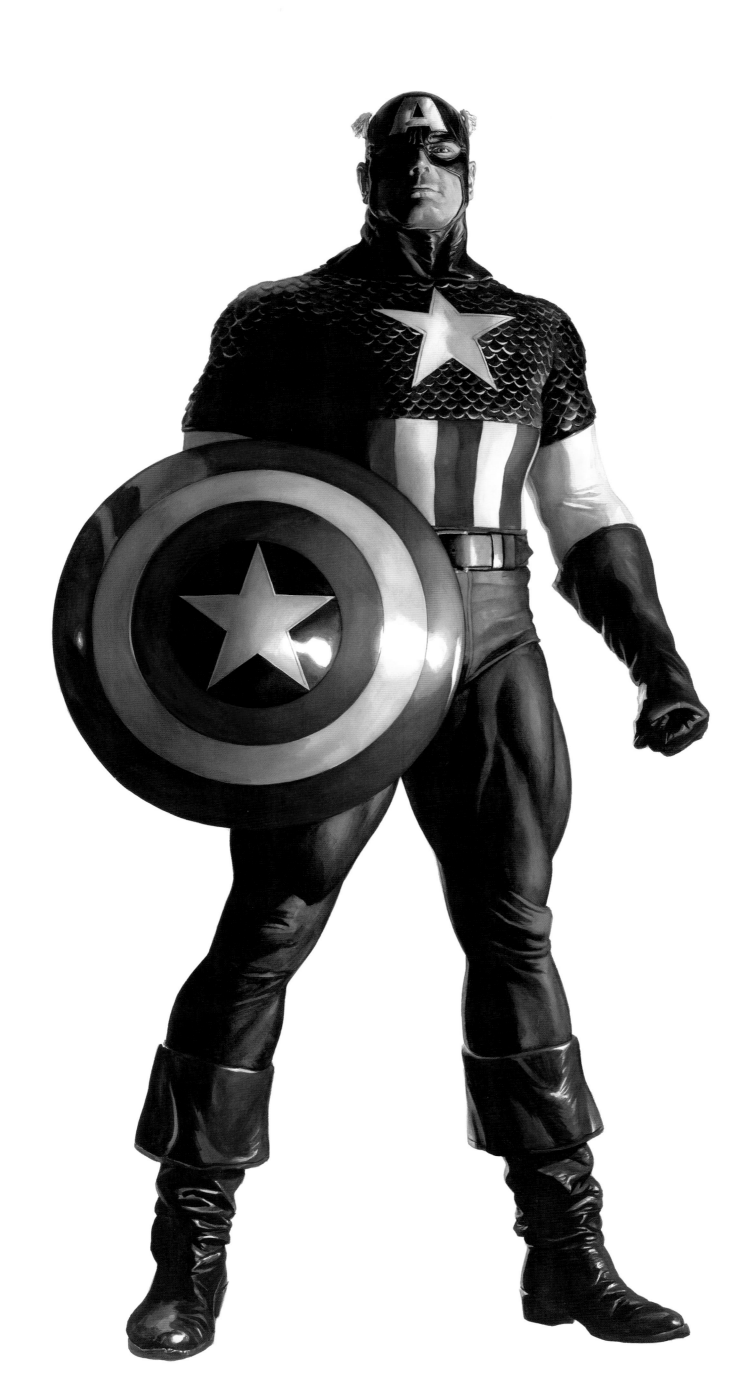

CAPTAIN AMERICA

I believe that while there are multiple ways to portray Captain America in art, sculpture, or on film, there is also a core look that Jack Kirby created with his work that gets lost with too much reinterpretation. Cap's costume is one of the purest in comics history. The effect of short sleeves (blue at the top and white arms) feels subconsciously like a figure who is ready to do hard work, having rolled up his sleeves for the tasks ahead. The striped midriff uses that element of the United States flag to a well-balanced position on his body. His shield, revised from triangular in shape to round, is one of the most recognizable items in popular culture. Distinctive elements like his flared buccaneer- or pirate-style boot cuffs grant a dramatic weight to his lower body, indicating how his grounded form uses his feet on equal par to his fists. The classic winged mask is a point overthought in modern times, where the instinct is to streamline the head by covering his exposed ears and flattening the wings. I feel that it is an essential part of his particular silhouette to see the wings and ears poke out, and I do my best to render the strength of that visual every time I paint him. I feel that the original costume is perfect as is, so to aid in this perspective, I used a modified sculpture to pose, which I painted to imitate the dark navy color of a true American flag. The traditionally brightly hued costume, deepened in tone, makes for a more credible figure that one can picture in action. The form that Kirby drew grew in size over the years, as his own artistic evolution granted the character a physical heft that has become identified with the Steve Rogers/Captain America heroic idealism. The effect of Cap wearing a light chain mail isn't meant to add bulk but to simply define and protect his chest. I reason that he would have a leather mask, form-fitted so his very expressions have weathered it over time. The need for a helmet and body armor is an encumbrance that would get in his way. Most of the greatest super hero designs represent the human body as a streamlined shape of naked muscle with color markings. This view has always presented our forms as the greatest weapons we have.

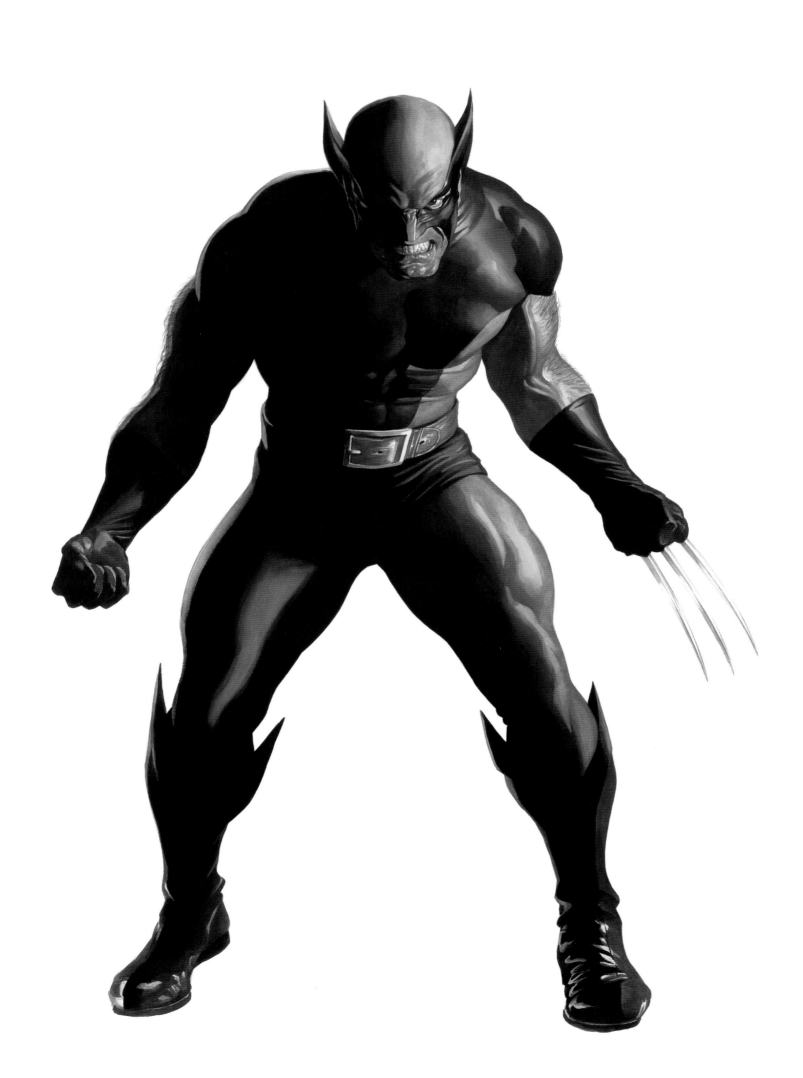

WOLVERINE

The look and feel of Logan/Wolverine is the result of the many creators who each contributed an essential piece of the character's look. The idea to make Wolverine a Canadian super hero prompted the adoption of the small, North American mammal as the character's inspiration, which had mostly to do with the cool-sounding name. John Romita Sr. designed him to have a clawed, feral, short-eared costume with whiskers drawn on. Someone else decided to color his costume yellow, blue, and red, and he was eventually launched and refined by other artists. When Dave Cockrum illustrated the "new" X-Men, he established Logan's unique hairline, which looked the same out of costume as in it. Once John Byrne took over the series, his embrace of the character as a particular favorite amplified Wolverine's appeal. Byrne's hirsute embellishment of Wolverine, and the character's elevated underdog status, made him one of the most relatable heroes in comics history. Eventually, Byrne added what is known as the "brown costume," which Wolverine would wear off and on for years to come. As a kid who saw this evolution firsthand, it wasn't hard to understand Wolverine's ascent to superstar, and I particularly loved the more earth-toned look that linked him to the scrappy animal he is named for. A life-size head bust I designed, sculpted by Mike Hill, is what I used to pose for lighting this mostly unchanging design to Logan's face and mask.

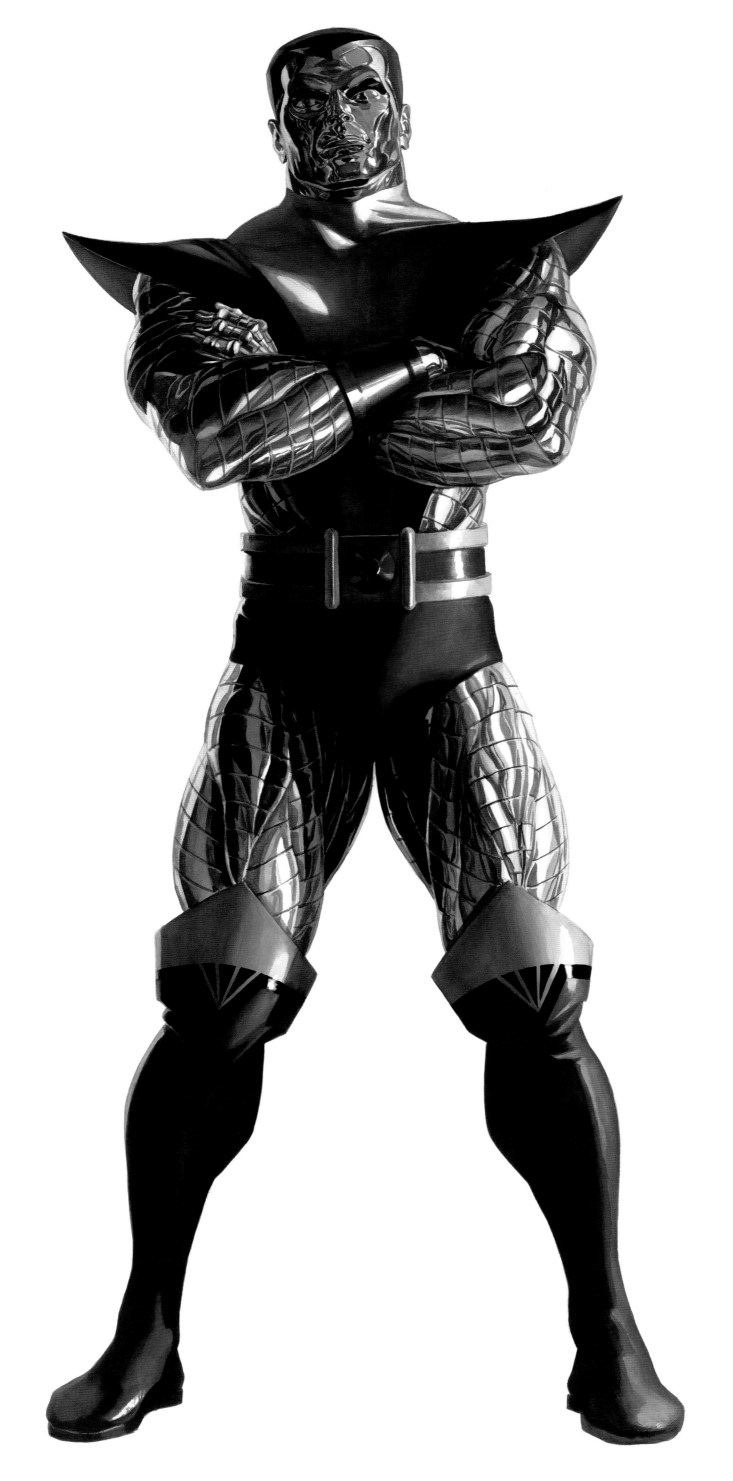

COLOSSUS

When I got my first X-Men comic in 1976, it was no. 100, and I was most taken with the tall, metal-skinned Russian with the nifty shoulder pads. Within Colossus also lay my general confusion with the new X-Men. I was familiar with the original team at the age of six, and I saw the new members as less-simple definitions of what kind of mutant variations they represented. Storm was a manipulator of elements, but not as easy to decipher as Iceman. Wolverine was a feral creature, but then so was Beast and also Nightcrawler, so it took investigation of their nuances to fully see their differences. Colossus was a metal man unlike a robot or a metal suit like Iron Man. The idea of an "organic metal body" was something cool and unique, but it took some getting used to. Colossus was another Dave Cockrum co-creation, and he wore the impressive clothes of a hero I always felt could lead the group. Since his characterization as a young mutant never fully went away, Piotr Rasputin/Colossus is a character who has the potential to be an even more popular hero were he to assert himself further. As Marvel's own man of steel, I have always been drawn to him as a hero, and I make my best effort to paint his appearance as cool as I've always seen him to be.

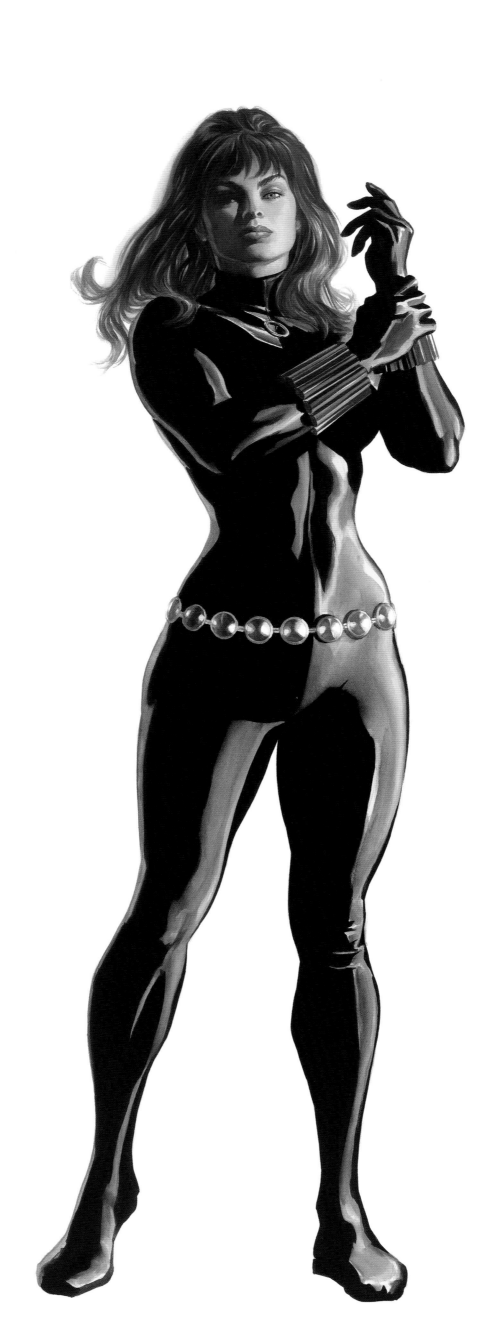

BLACK WIDOW

The "catsuit" design given to Natasha Romanoff by John Romita Sr. is one of the coolest redesigns in comics. Dressed previously with veils, capes, and fishnets, the Iron Man villainess turned rogue agent from Russia was looking for an upgrade that matched her cool code name. The sleek but personally indistinct black costume established her mode of operation as a mostly covert one. She may have had footwear that allowed her to stick to walls, but she was no imitation of Spider-Man (although her new look was introduced in his book). The circular belt cartridges and high-teased hairstyle were both holdovers from styles of the late sixties. Neither of these details seem dated, though, and are elements that I like to keep when I can depict a continuation of aesthetics from another era. Black Widow is now a greater heroic inspiration for fans as she is seen as the preeminent female super hero in Marvel's films. Much of her history was in partnership with others like Hawkeye, the Avengers, and Daredevil, but now her independent value as a solo hero eclipses all of her past associations.

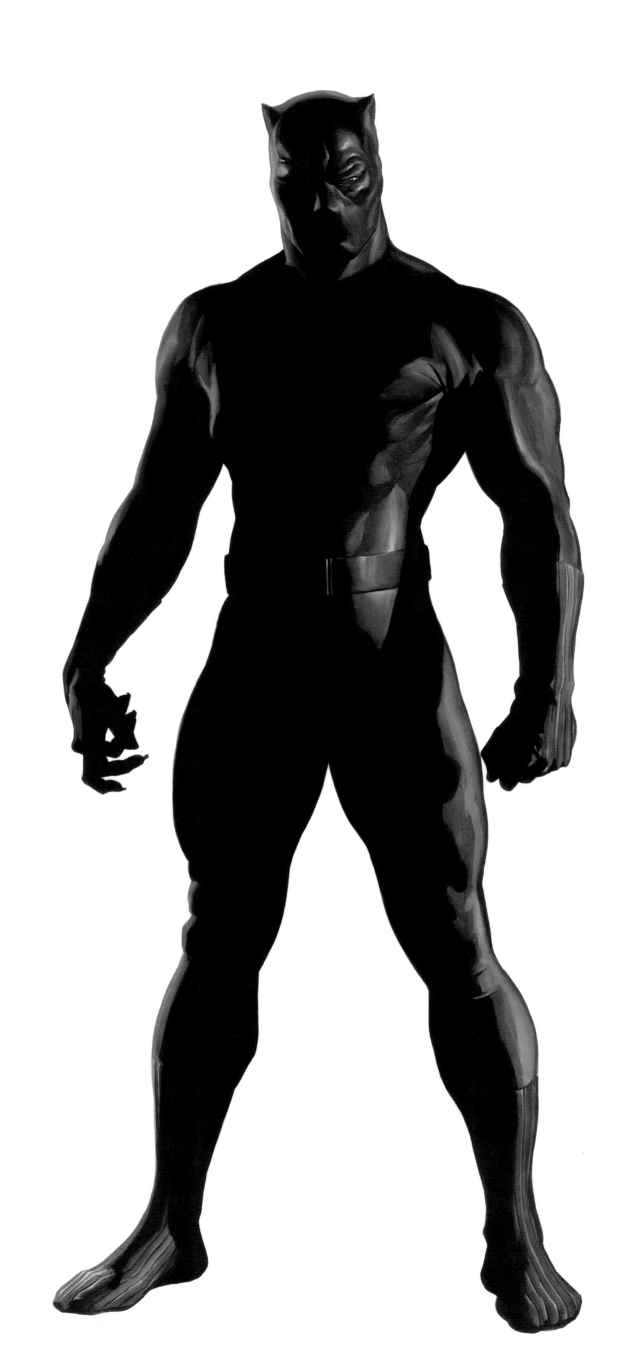

BLACK PANTHER

It's hard to imagine that Jack Kirby's original concept of "Coal Tiger," with a striped and brightly colored costume, would have made the same impact had he been introduced as the world's first Black super hero. Clearly, the refinement of this idea into the more striking and primal Black Panther was an improvement. It was the subtlety of Kirby's rendering that guaranteed this dark-clad, pointed-eared design wouldn't be confused with any others like it. The 1966 arrival of the African king/super hero changed comics forever and stood as a remarkable act of bravery to expand representation in the art form. The collision with the real-life political group was an accidental occurrence that had relatively little impact on the character's continued legend. His background as a monarch for an advanced African nation gave all kinds of material to build upon creatively, and an ideal society to aspire to. Kirby made an impact with first establishing the character in the Fantastic Four's comic, and later when Marvel gave Black Panther his own book. Within Black Panther's own book, Kirby made the mask look more like a panther's skull shape and added fingertip claws, which inspired artists and movie designers for decades afterward. When I draw the costume, I try and keep that subtlety of seeing the cat face emerge from within the form-fitting mask in a shadowed, organic way.

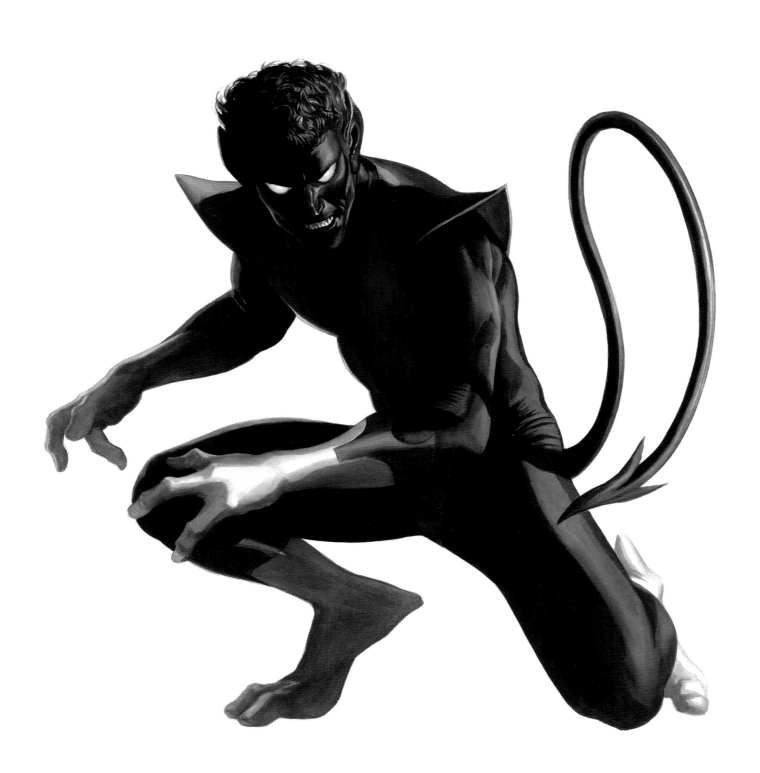

NIGHTCRAWLER

The character concept that goes the furthest back for artist/creator Dave Cockrum is Nightcrawler, who he had designed years before he added him to his line of mutants for the new X-Men. When Cockrum was still serving in the military before starting work in comics, he developed this devilish-looking hero. He almost gave Nightcrawler to another group lineup he redesigned years before the international idea of a superteam took hold at Marvel. Nightcrawler did not specifically come from German origins, but it fit him well in the years to come when writer Chris Claremont would build on that background to create the Kurt Wagner persona. Distinctive to Cockrum's design is the curly hair he gave Nightcrawler, but quite often this is a detail that artists forget or remove from his look. The blue-black tint to his skin and hair is a challenge to recreate in a painting in terms of how dark it should be taken. His costume's black areas are a full, solid black that most everyone who illustrates him gets right, given that they have the red and white areas to offset it. Nightcrawler and Colossus share the wide shoulder pad aesthetic that Cockrum used on quite a few of his most distinctive character designs. Although that detail has never been translated to film, it still recurs in the comics medium as a visual that possibly only works there. I'd be happy to see it in a movie, though.

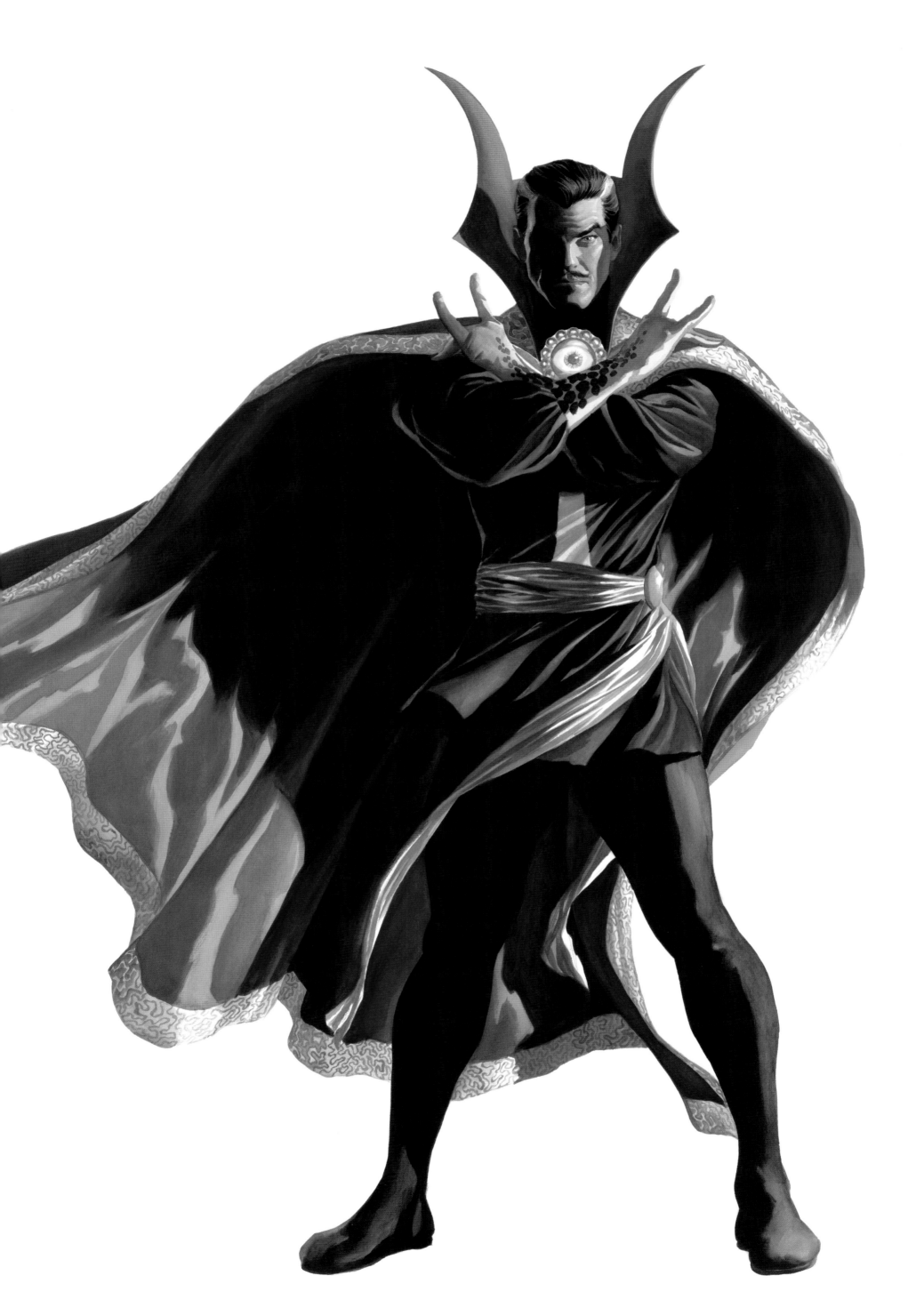

DOCTOR STRANGE

One of Steve Ditko's greatest contributions to comics is his concept for this sorcerer super hero and the fantastic, artistically imaginative realms he would visit. Since the doctor could project his body through space in a ghostly "astral form," he could travel to dimensions beyond our own and encounter unnatural threats that pushed the limits of what artists had drawn before. Throughout early twentieth-century fiction, much was made of Caucasian protagonists going off to the Far East to find enlightenment and to master either magic or fighting skills. Doctor Strange's story becomes the surviving popular take on this trope, where everything he is comes from that journey. The cape and amulet of Strange are his most distinctive emblems, with the graphic shape of a demon reaching upward on his shirt. Ditko was not intentionally clothing a super hero initially, but the tinting of blue on the black of Strange's clothes led to the colorful augmentation most heroes go through. Strange is also one of Marvel's group of older super heroes who sport gray temples, which was itself a bit of an innovation for the company in seeking to embrace a wider range of people and ages who make up the genre.

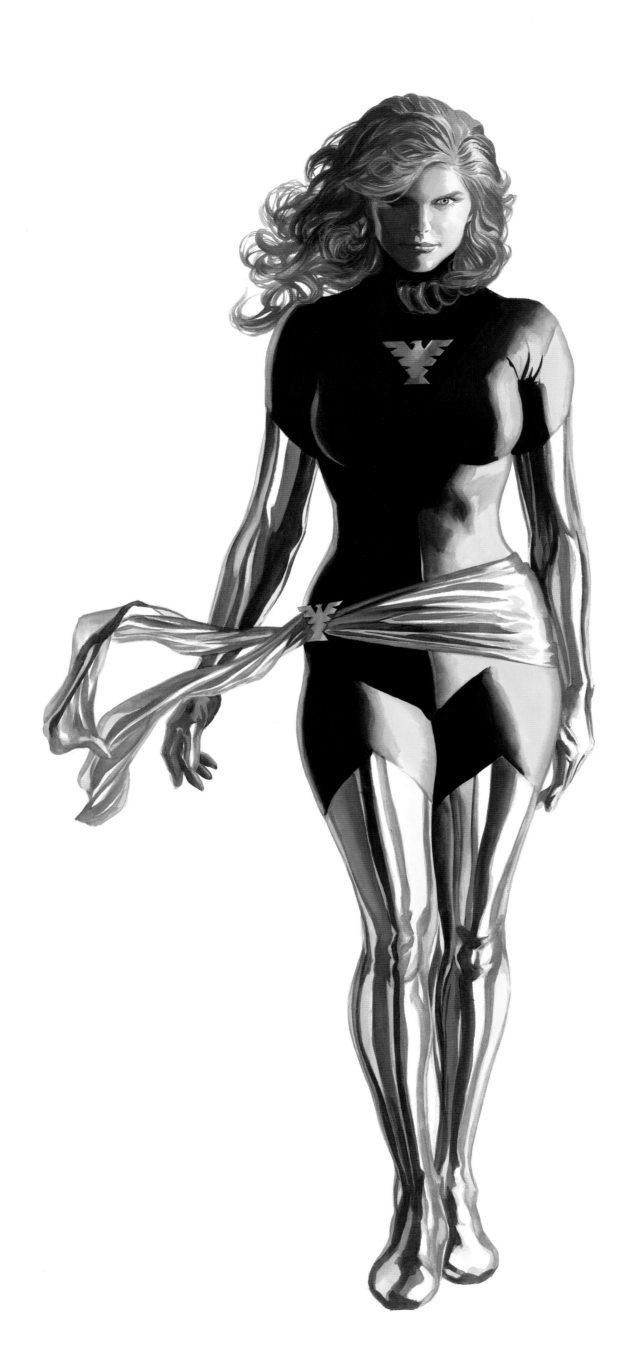

PHOENIX

Another of Dave Cockrum's great contributions to comics is the refresh-
ed look to Jean Grey, who matured from Marvel Girl to goddess-level
Phoenix. The buildup that writer Chris Claremont and artist Cockrum
made to Phoenix's birth (or rebirth) was the culmination of their overall
takeover of the original X-Men. Now, only Cyclops remained the same,
albeit with a nifty new visor. Cockrum's translation of the green and yel-
low colors of Marvel Girl's costume into chartreuse and gold hues, with
the inclusion of opera gloves and thigh-high boots, was a staple of his
approach, but it elevated her to look as impressive as the powers she now
manifested. Jean may not have been perceived to be as "cool" a mutant
as her original teammates, and this inspired the idea of advancing her
telekinetic gifts to a level where she was now the most powerful being
on Earth. Her story would lead to one of comics' most beloved, memo-
rable, and argued-over epics, where she became corrupted as the Dark
Phoenix and would endanger the universe itself before she heroically
ended her own life. Things didn't end there, of course, but this tale marked
one of the most impactful moments that grounded the X-Men as the
most consistently popular comic book team ever. I read this important
issue when I was the impressionable age of ten, and I always saw it as a
game changer in terms of my appreciation for the art form itself.

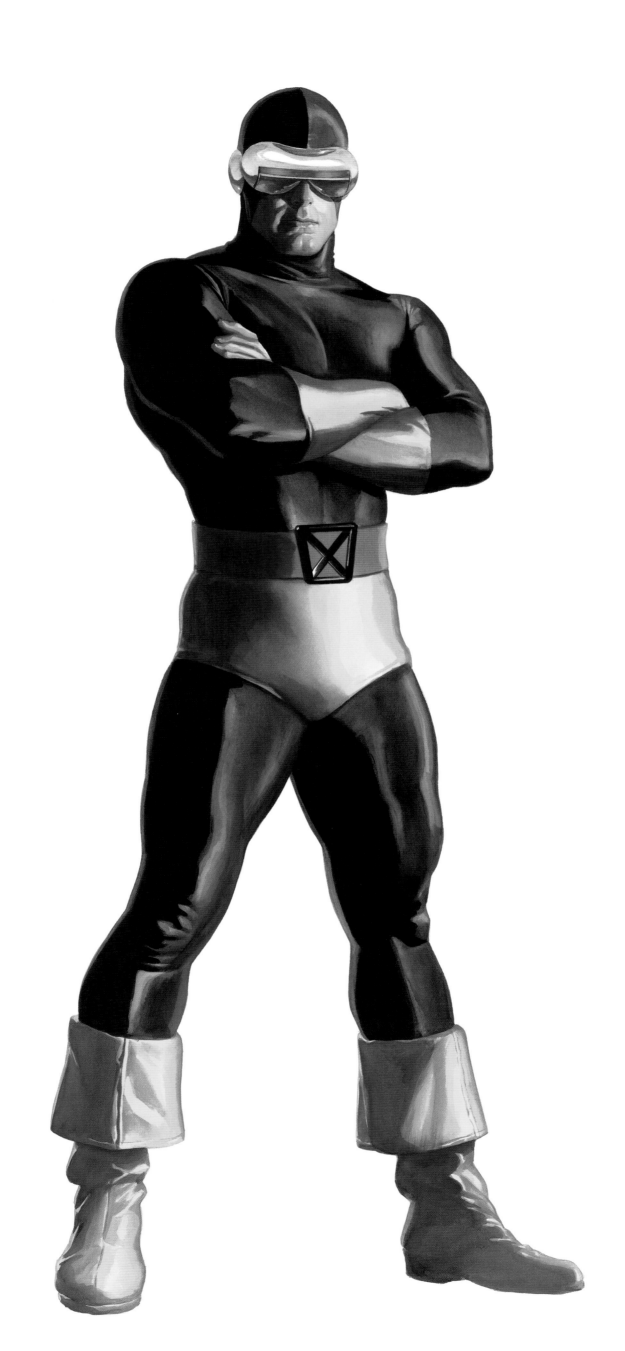

CYCLOPS

Since I say that I love the boring, responsible guys who make sure their teammates do what they are supposed to, it will come as no surprise that Cyclops has always been my favorite X-Man. From a power-level grading, the guy who can blast things with a look seems like he'd be the one you would listen to anyway. The straitlaced Scott Summers always seemed to carry the burden of his team on his shoulders, as well as the confining nature of his dangerous super-power. His loss of Jean Grey/Phoenix would also come to define him as a wounded figure. Even when they brought Jean back from the dead, he didn't seem to stop being that person who had been through too much tragedy. The simplicity of his design was a sign of his nature. Despite updates to his costume over the years, he always wore a slight revision of his original black-and-yellow team/school uniform. Since he and the others were teenagers when their teacher, Professor X, originally formed the team, the impact of those days always seemed to act as a subtext to Cyclops' personality in that he didn't want to move on from that first bonding experience with others who were like him. Aside from updated visors or head coverings (or no head coverings), Cyclops has mostly worn a dark blue or black nondescript super hero outfit, as if it were the mutant school's standard-issue uniform.

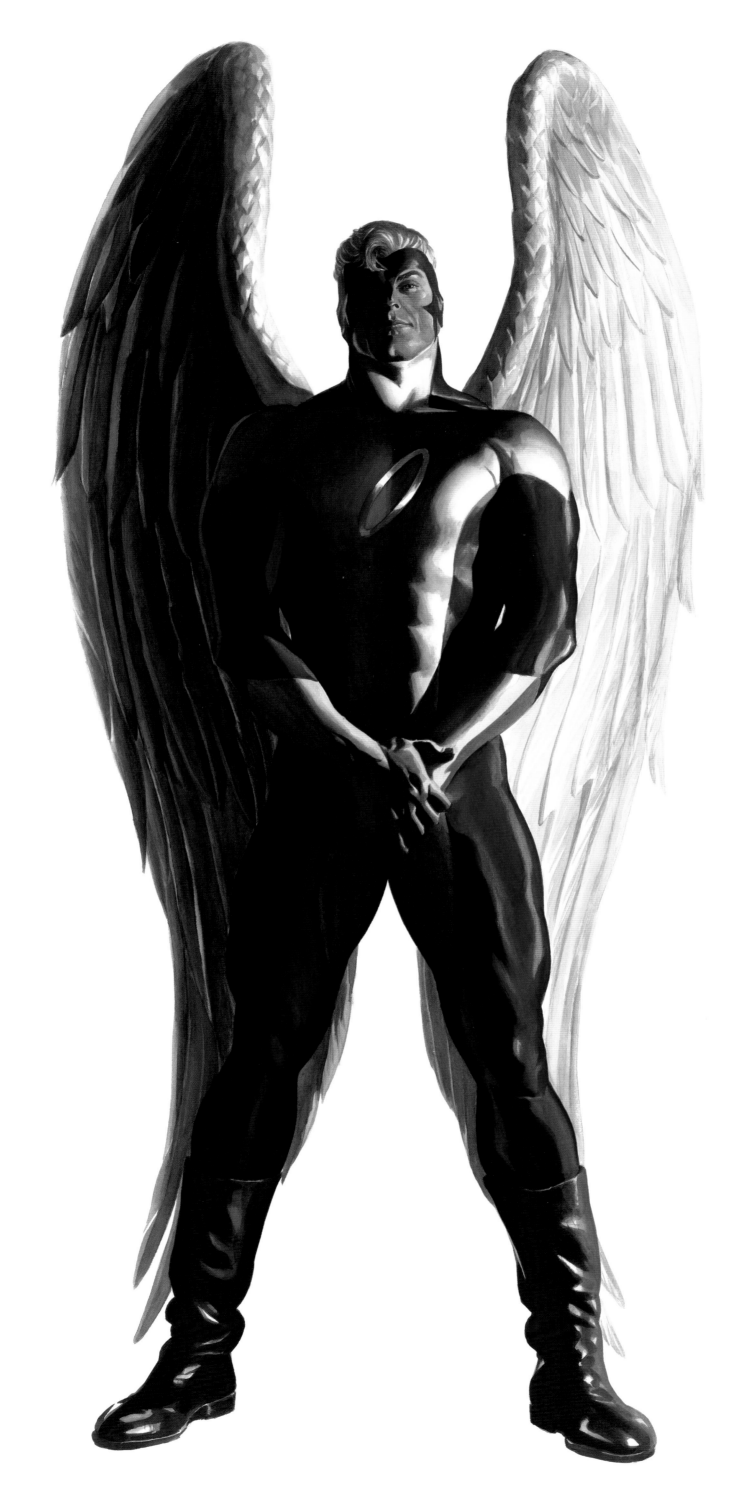

ANGEL

The X-Men's original emblematic star who was featured flying above their book's logo, was Angel. The sight of the hero with white wings would remind people of one of the heavenly emissaries for which he was named, and was also the simplest graphic representation of a mutant to date. The power of flight is immediately assumed to be his mutant ability, and the visual combination of two species was easy to understand. I feel a personal connection to Angel because of his being featured on the cover of the second issue of my career-establishing series, *Marvels*. The cover was turned into a promotional poster by Marvel, making it the image most readers first saw of my work. I grew up with both the redesigned Neal Adams Angel costume, and got to experience the Jack Kirby original uniform through reprints. This character may have been the prototypical mutant who wore the most basic version of the team's gear without any alterations over the years. When the group varied their look by using differentiation through color, Angel got a somewhat mismatched, primarily yellow outfit. Adams created a unique suit in black and white that would put Angel on another level. His time spent in the group the Champions (along with fellow X-Man Iceman) gave this look an update to red and white. This suit would be used in many of his greatest stories, arguably becoming his most iconic look.

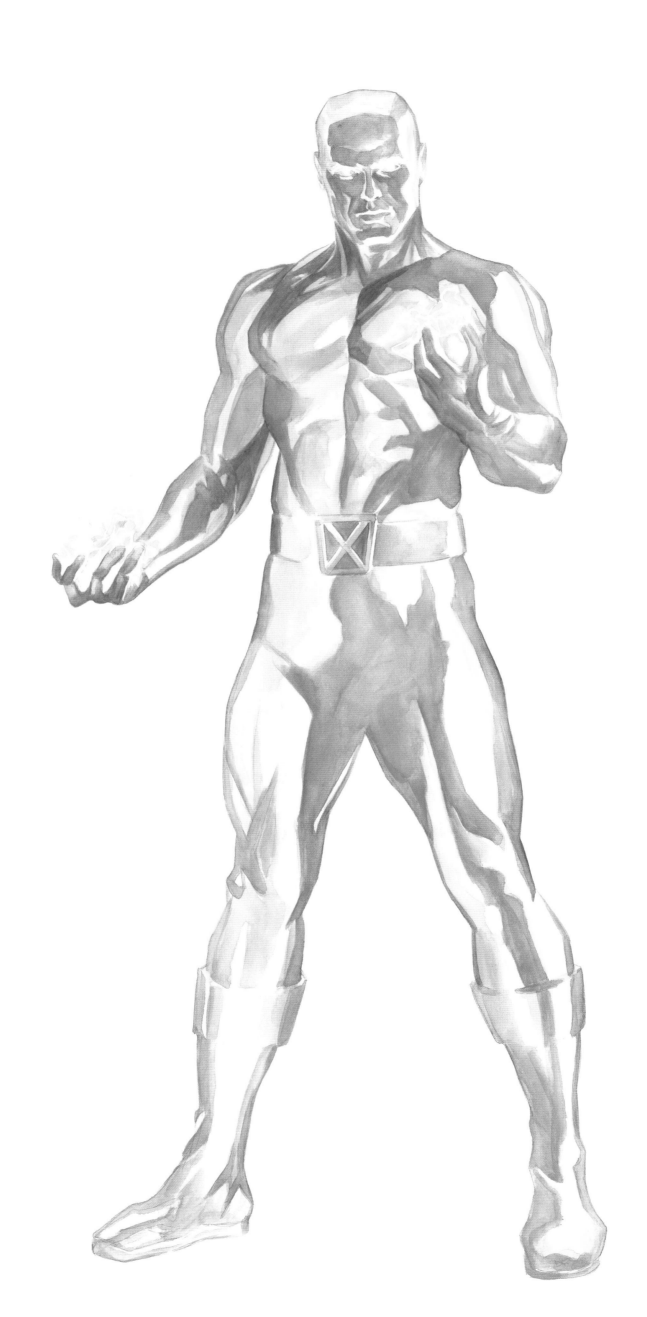

ICEMAN

I was first introduced to Bobby Drake/Iceman in the first comic ever purchased for me, *Spidey Super Stories* (a tie-in to Spider-Man's appearances on *The Electric Company*). I may have known of him before the Human Torch, making the frost-covered Iceman my first elemental hero, a feature I adored. This early exposure made every other time I saw him stand out. I was excited by his look of blue-white/translucent hard edges, which I found easy to distinguish from the smooth, chrome-line-accented Silver Surfer. Any character that was an inhuman color always appealed to me, and Marvel Comics had a lot of them. Whereas Iceman's original appearance in the *X-Men* series was as more of a snowman, Jack Kirby refined the look to be hard ice before he left the book as penciller. The "new" X-Men split up the old team, leaving only Cyclops behind at first. But as the years went on, Iceman would remain a recurring member. In the early eighties, he joined Spider-Man, along with a female fire elemental named Firestar, on the cartoon *Spider-Man and His Amazing Friends*. This popular kids' show likely introduced a far greater number of people to him, as well as to many extended members of the Marvel Universe, like the X-Men themselves (who made their television debut on this program). In painting my portrait of Iceman, I studied a translucent bust for the light distortions that are similar to ice.

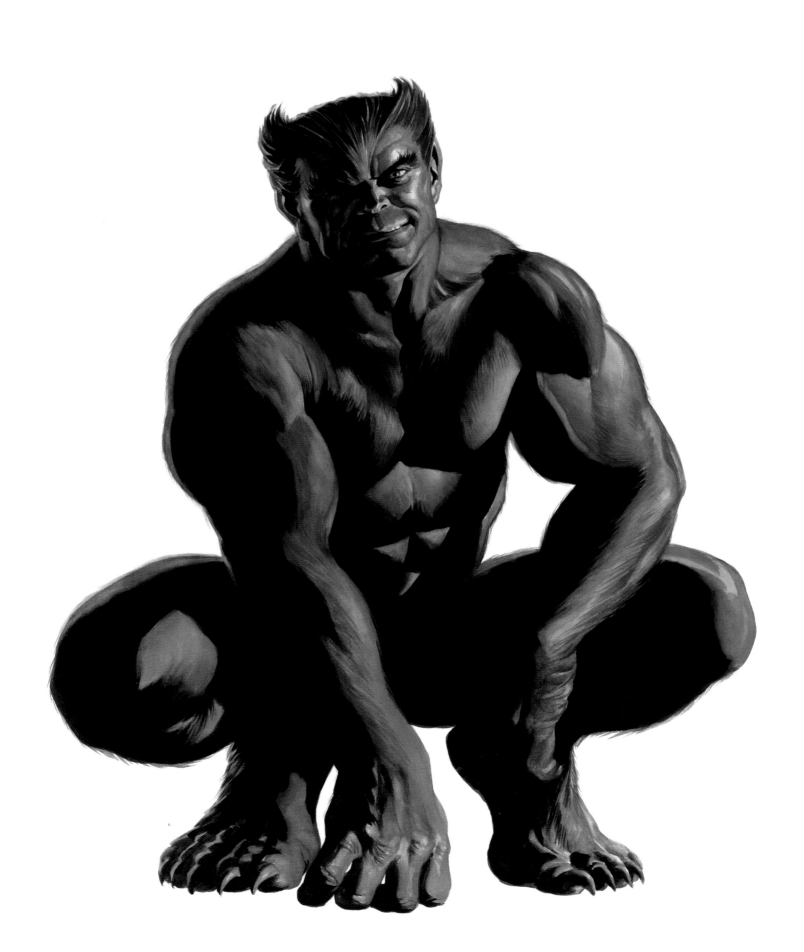

BEAST

The classic X-Men's most popular member may well have proven to be the Beast, but long after he was part of the team. When he was first designed, he was the least exaggerated of the Kirby Hulk/Thing body type, with only hairy arms and feet to relate his beastliness. Initially, the Beast didn't embody the potential of his code name, but other creators would fix that. With an experiment done on his mutant genes, Beast/Hank McCoy caused his own transformation into a more fearsome, fur-covered, pointy-eared, fanged, and clawed creature. His fur coloring started as dark gray but switched over to a somewhat standard deep blue (which is repeatedly used to highlight black costumes, eventually leading them to become blue altogether—as with Spider-Man, for example). This change in his coloring, and his induction into the Avengers, gave the Beast a new sense of identity that made him popular with readers. He also joined the Defenders along the way, as well as X-Factor, and then back to the X-Men again. The Beast/Hank's brilliant mind was balanced with his charming, easygoing nature as he accepted his physical circumstances and even embraced them. The timeless version of this character is one of Marvel's most likeable personalities.

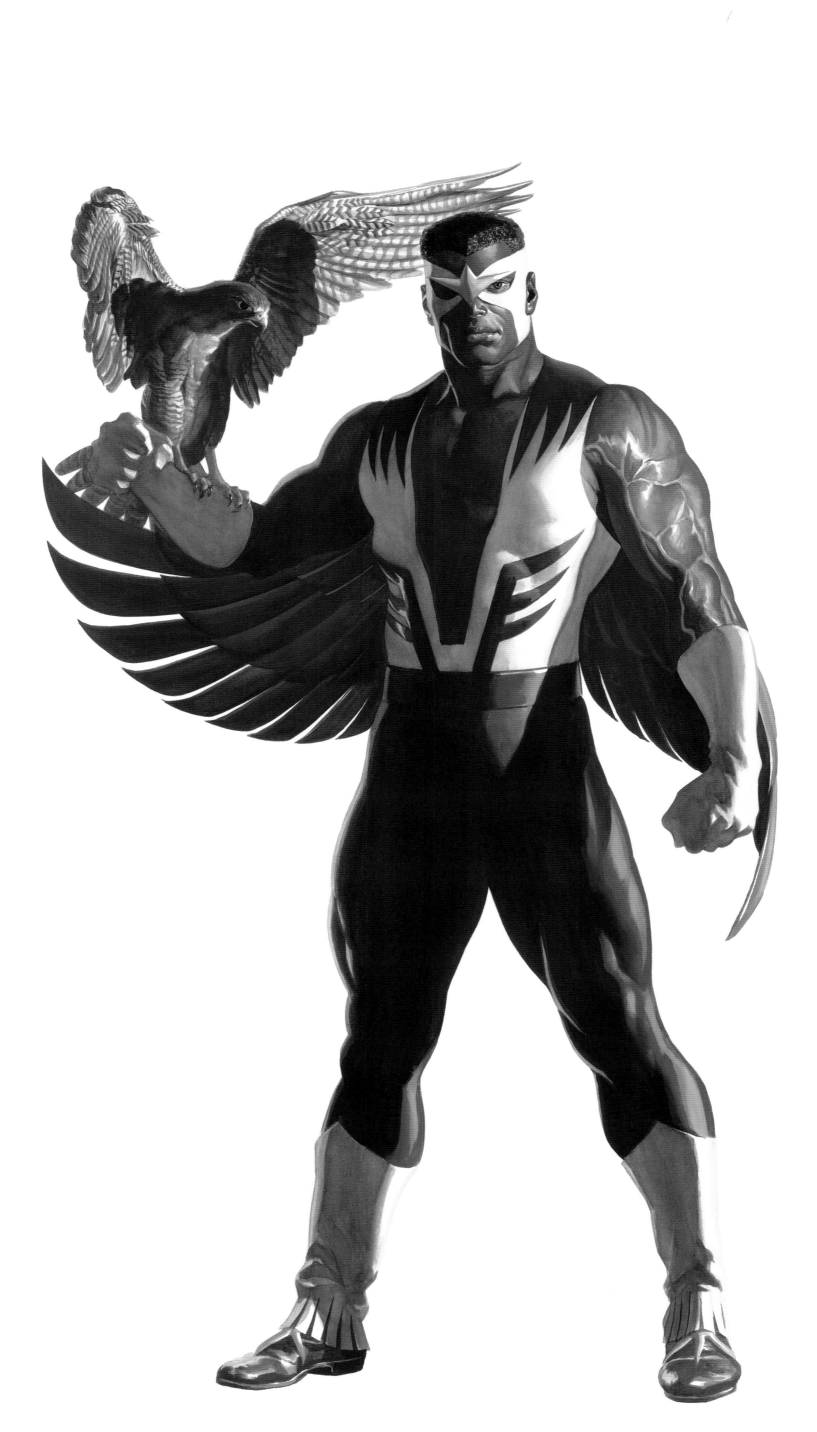

FALCON

Like many who were introduced to comics in the seventies, the way I got to know Captain America was in equal billing with his partner, the Falcon. Marvel's second Black super hero was also the first African American super hero, as T'Challa/the Black Panther was from Africa. The early design of Falcon didn't feature him as a winged creature but as a tropics influenced, green-and-orange-garbed hero. Redwing, his actual falcon companion, was there at the start, which would slowly affect his look becoming based on the bird. Falcon then changed to a white-and-red costume, with only a single glove for Redwing to perch on, and a propelling hook-line "bird claw" for Falcon himself to swing from. Black Panther then stepped in to upgrade Falcon with a set of wings. Falcon's small wings went where the corresponding mammal appendages would be, under his arms and not out of his back. He looked more like he could glide than soar, but Falcon's flying enhancement would be a welcome asset in his adventures with Cap. The classic winged outfit for Falcon would become his most identifiable look for years, even as more practical augmentations would be added over time. His exposed arms hinted at a raw strength that is subdued the more he gets covered up. Having designed the current suit for the hero, I feel that I didn't improve a great costume that already worked graphically if not functionally.

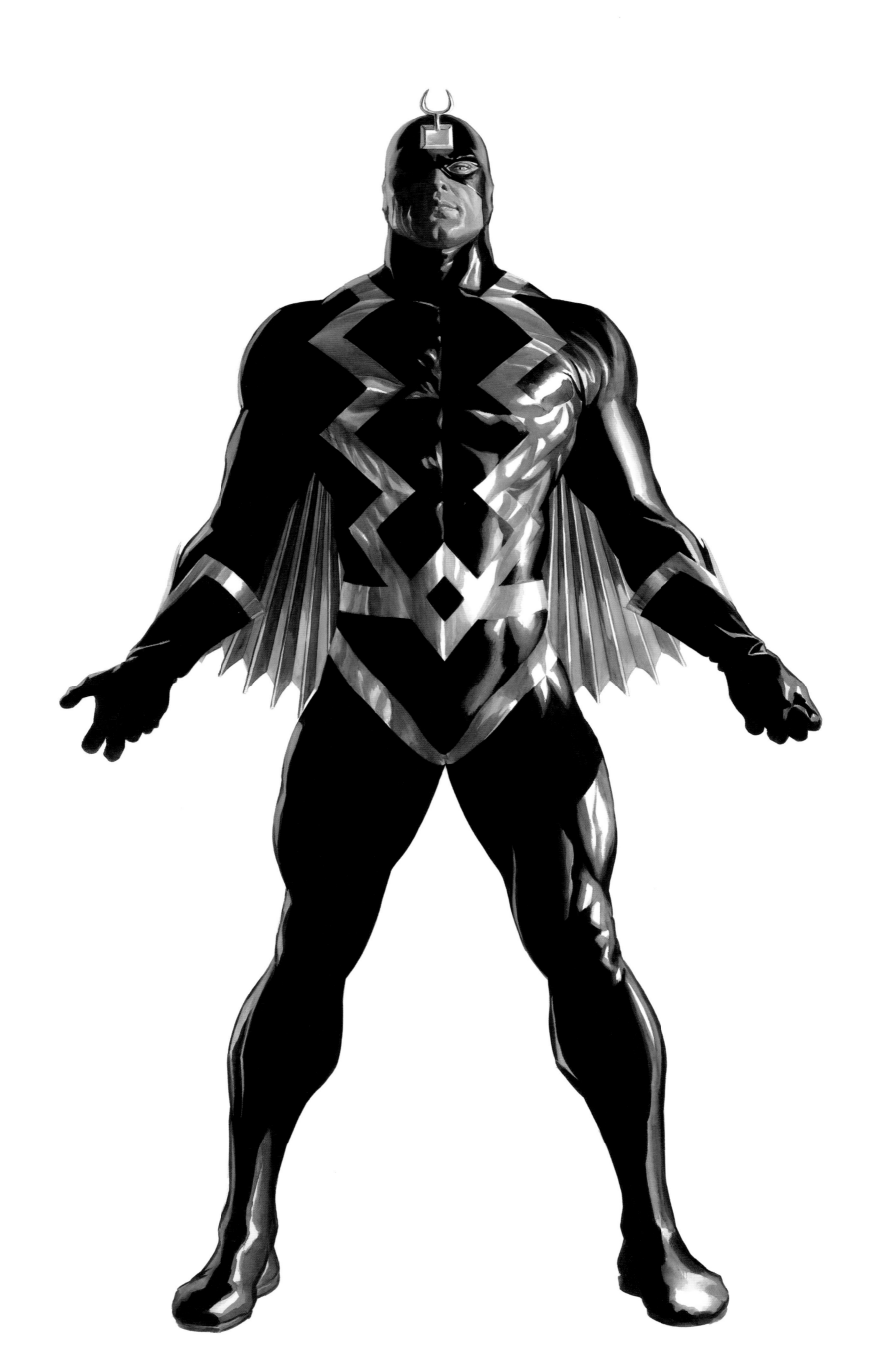

BLACK BOLT

Legend has it that Jack Kirby brought in concepts for Black Bolt and Black Panther at the same time, having been tasked with creating new lead hero properties to launch from the *Fantastic Four* book. The objective was allegedly to pull something similar to a super hero TV sensation of 1966 and make it Marvel-style. Black Bolt kicked the fantastic monarchy angle of the Panther up a notch by establishing a whole royal family of superhuman characters who were uniquely varied in their inhumanity. The actual kingdom of the Inhumans was a city of the future hidden away in the Himalayan mountains (the city's location was moved multiple times in the years that followed). As a notable representation of disability, Black Bolt was unable to speak. This limitation was a by-product of his immense power, where the slightest sound from his lips might level his surroundings. The slick black suit he wears has hardly been updated. Kirby translated an electrical graphic into the suspender straps, with folding steel fans under Black Bolt's arms and a tuning fork on his forehead. None of that sounds right on paper, but countless fans like me are entranced with the assembled design. The approach I've tried to assert is of his black suit having a wet, glossy look, avoiding the blue tinting that often happens to dark costumes in comics when highlights are added.

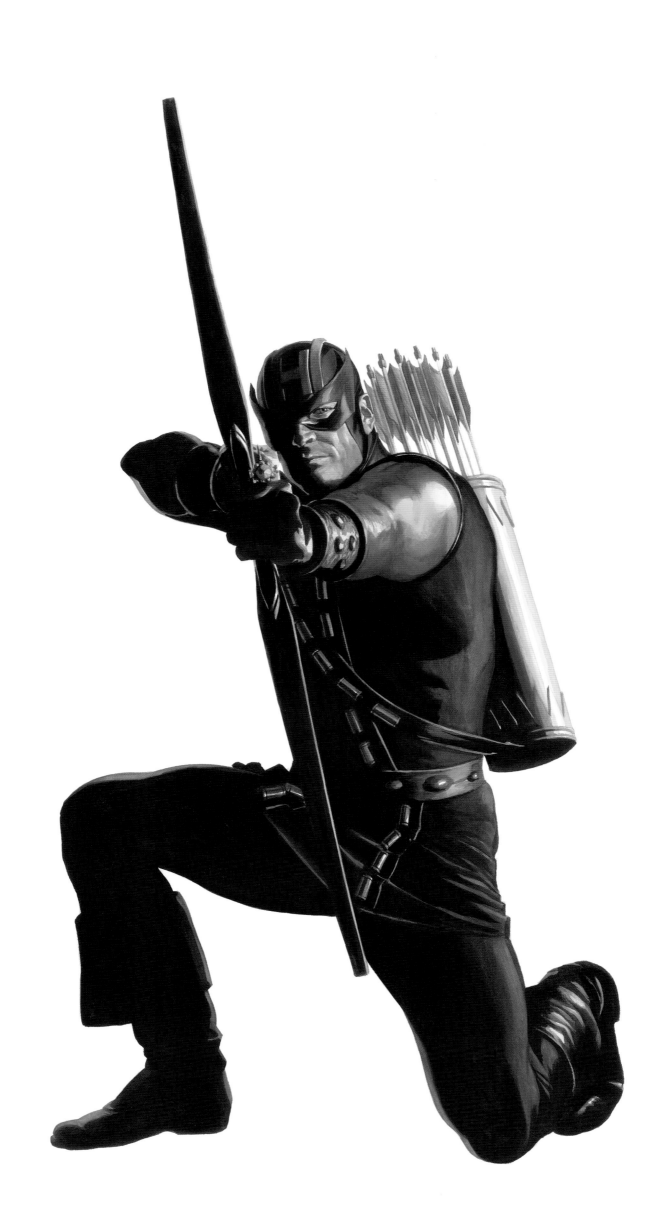

HAWKEYE

The purple Avenger is a longstanding pillar of that group, whether or not he was even their archer in residence. For a great period of stories in the late sixties, Hawkeye traded roles with Hank Pym to become the second Goliath. This period was the apex of John Buscema's run on the series, which is often felt to be the defining era of the group. Hawkeye's position on the team was closest to that of the "regular guy" on a team made of titans. He didn't have the burden of being a living legend (and man out of time) like Captain America, nor was he a god like Thor, nor an inventor genius like Iron Man/Tony Stark or Hank Pym/Goliath/Yellowjacket/Ant-Man/Giant-Man. Hawkeye's hard-won skills with a bow and arrow and his overall fighting adaptability was enough to make him an asset to this lineup of Marvel's greatest heroes. Hawkeye's original black-and-purple masked persona is a particular favorite of mine. His chain mail and buccaneer boots are something he shared with Cap, affecting a Medieval look. I always like to draw this masked identity version, as it is useful to have his identity concealed, especially as more people he needed to protect in his personal life were added over time.

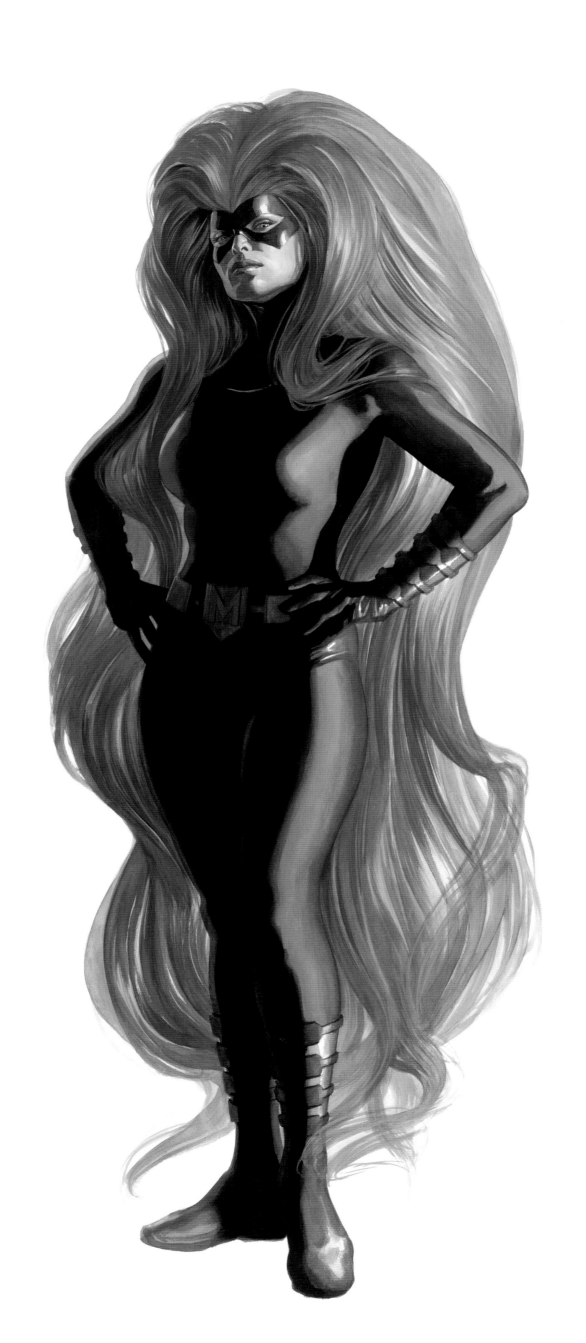

MEDUSA

Before the group known as the Inhumans was established or created, Medusa made her mark as a strong female adversary for the Fantastic Four. Partnered with the Frightful Four, a somewhat corresponding quartet looking to defeat the Fantastic Four in their book, Medusa became the breakout star of that team. Eventually throwing off her bad-guy association, she was revealed to have a more expansive background, representing a previously unknown culture and breed of humankind. She was the first Inhuman to cross over to the modern world, and we were later introduced to her family, which included her sister, Crystal, and their king (and Medusa's betrothed), Black Bolt. Given that Black Bolt couldn't speak, Medusa acted as his mouthpiece, but she also had her own agency, having previously left the Inhuman kingdom of Attilan, as she would choose to do repeatedly over the years. When Susan Storm Richards temporarily left the Fantastic Four, Medusa stepped into her spot on the team. Medusa has had a number of costumes over the years (including a green-colored standout by John Romita Sr.), and most of them favored purple/mauve tones. The masked appearance of many of the Inhumans bore no practicality, since none had secret identities and seemed instead to be cultural presentations of their Royal Family. I've always tried to establish an impressive bulk to Medusa's hair, considering its extended reach and ability, but the proportions are purely subjective.

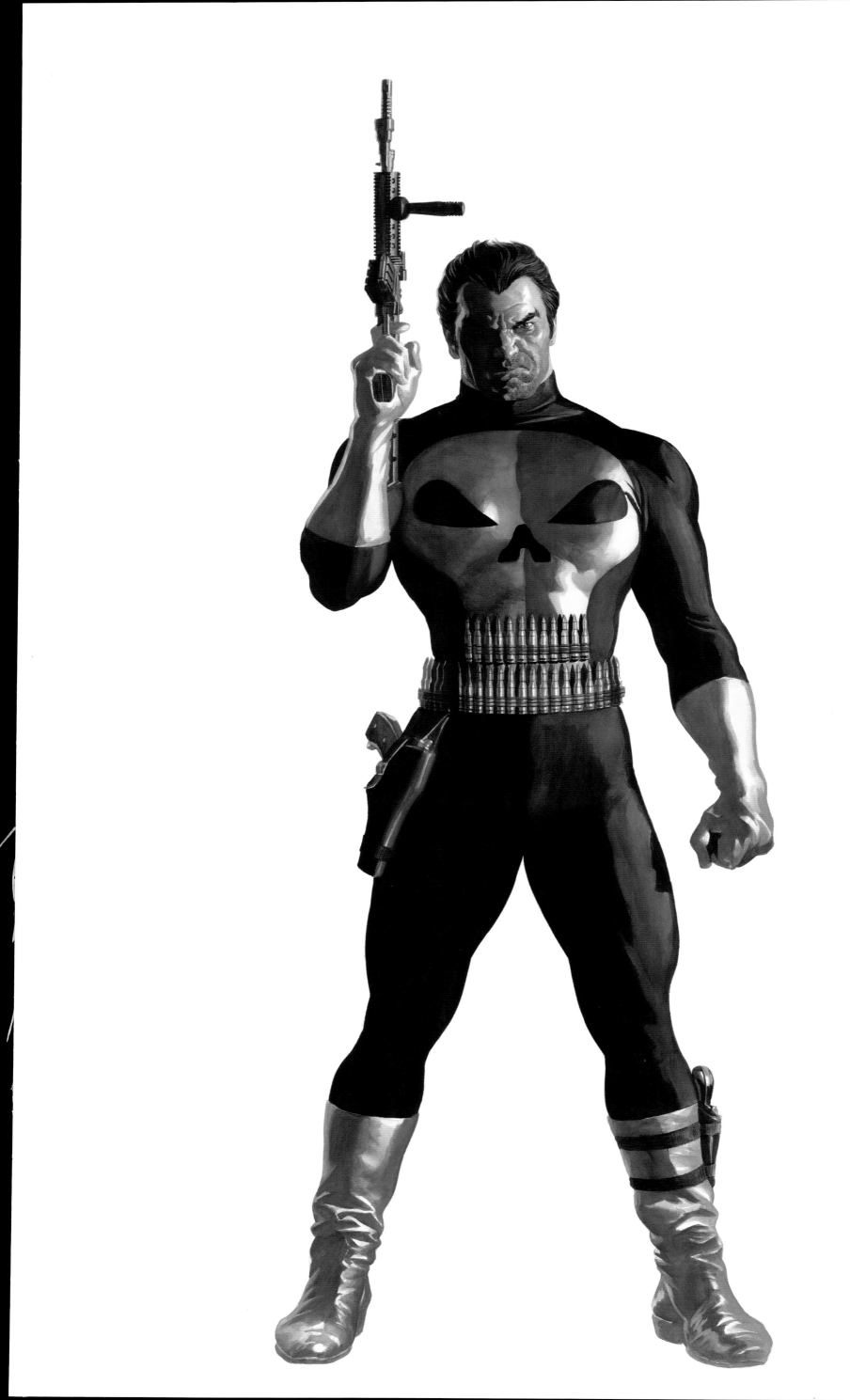

PUNISHER

Rounding out the portraits in this Marvel mural project is the purest vigilante antihero, Punisher. His popularity rose with contemporary culture's perception of crime being out of control and the entertainment world's depiction of vigilante justice as the only reasonable response. The first Frank Castle/Punisher concept sketch came from John Romita Sr., where he stylishly incorporated a skull chest emblem into a row of exposed bullets serving as its teeth. The Punisher's original white gloves and boots seemed to indicate a careful clinical precision to his violent work. The character's first introduction saw him tasked to assassinate Spider-Man (which, luckily, he failed to do), and he has mostly remained on the periphery of society's acceptable super heroes who don't kill people regularly (although Wolverine gets included somehow). The Punisher's story is one of incredible loss, which he responds to with unending vengeance. In some respects, the Punisher serves the purpose of showing the lessons of a life compromised, walking the line between defending the innocent or being a greater threat himself.

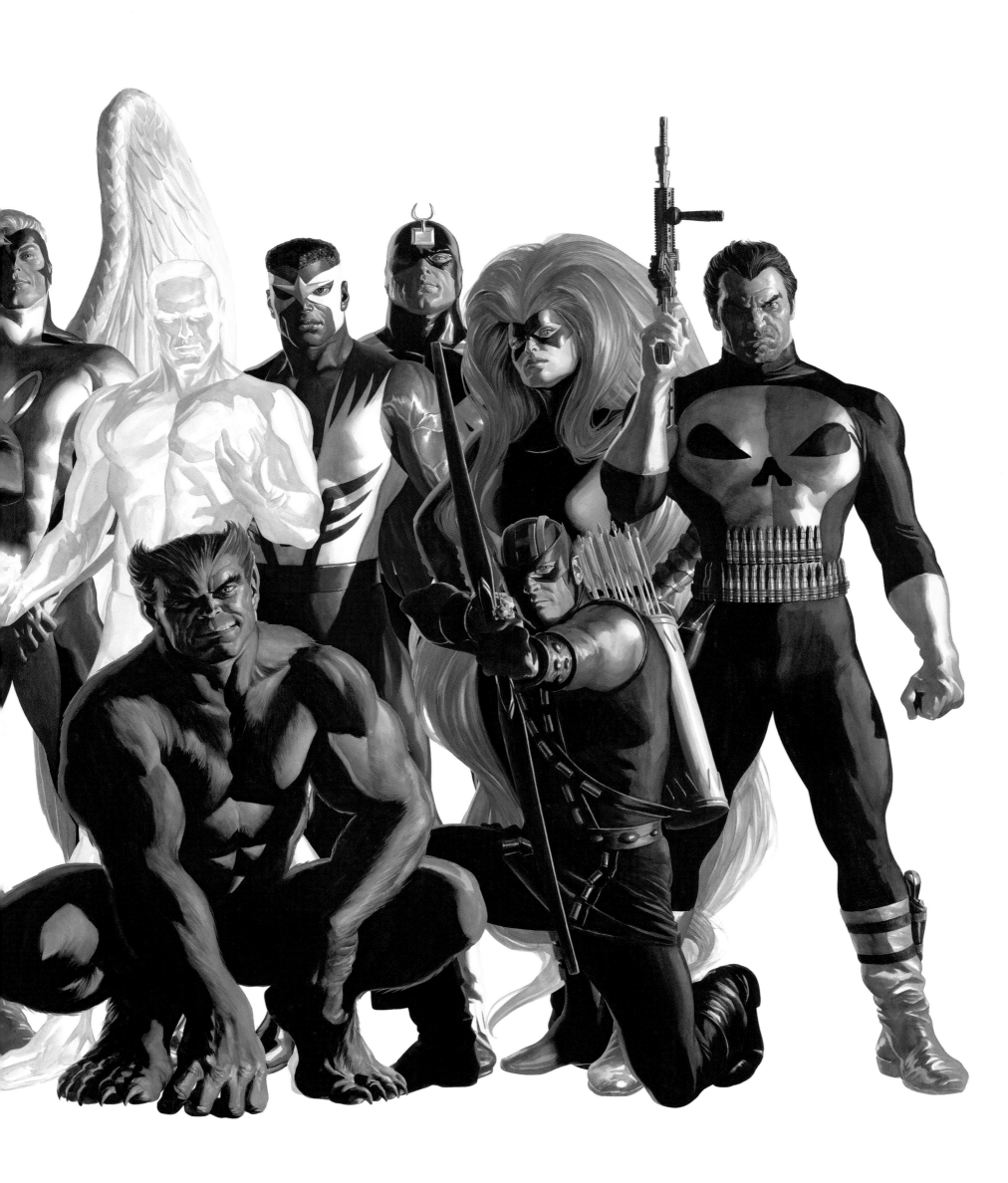

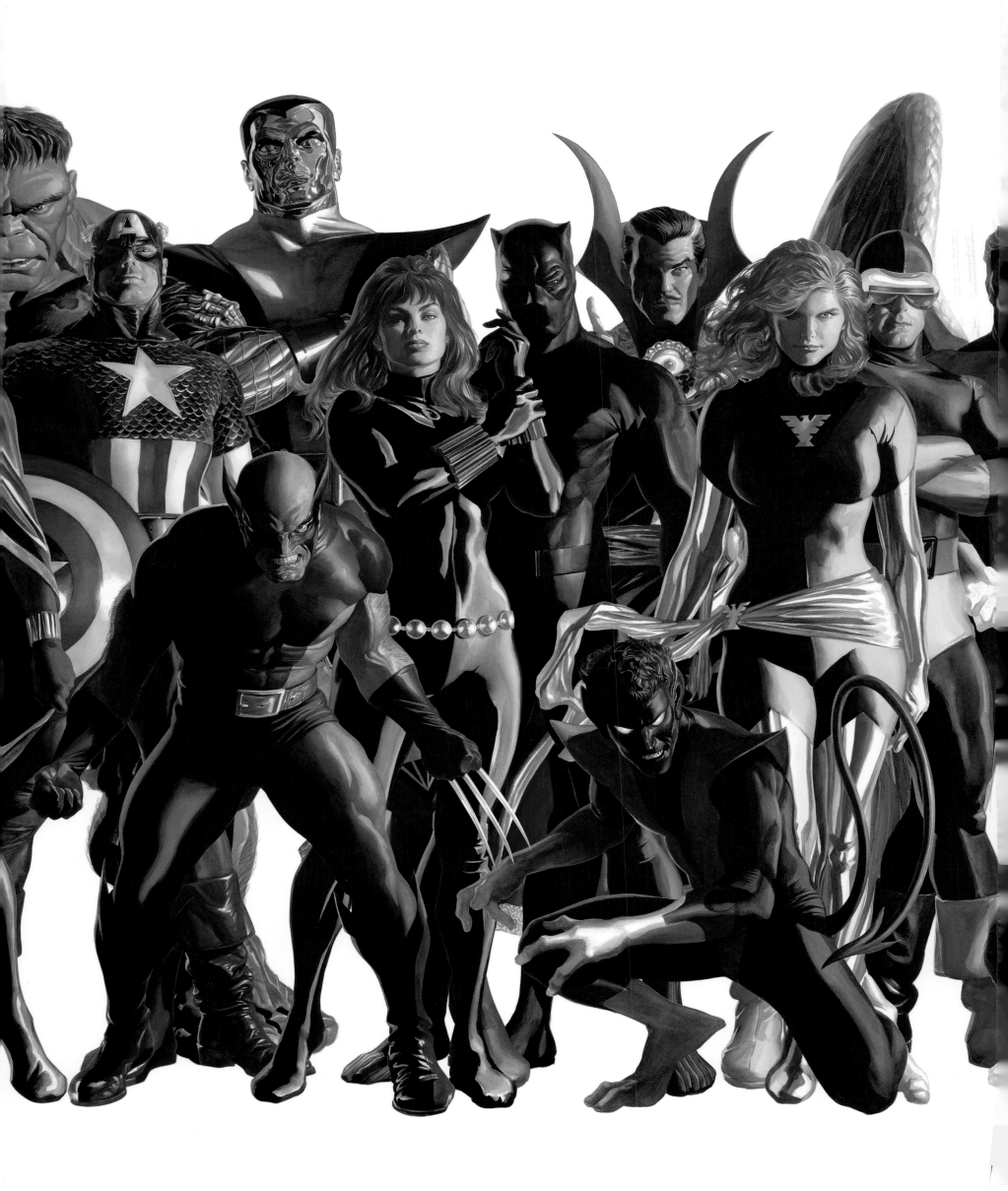

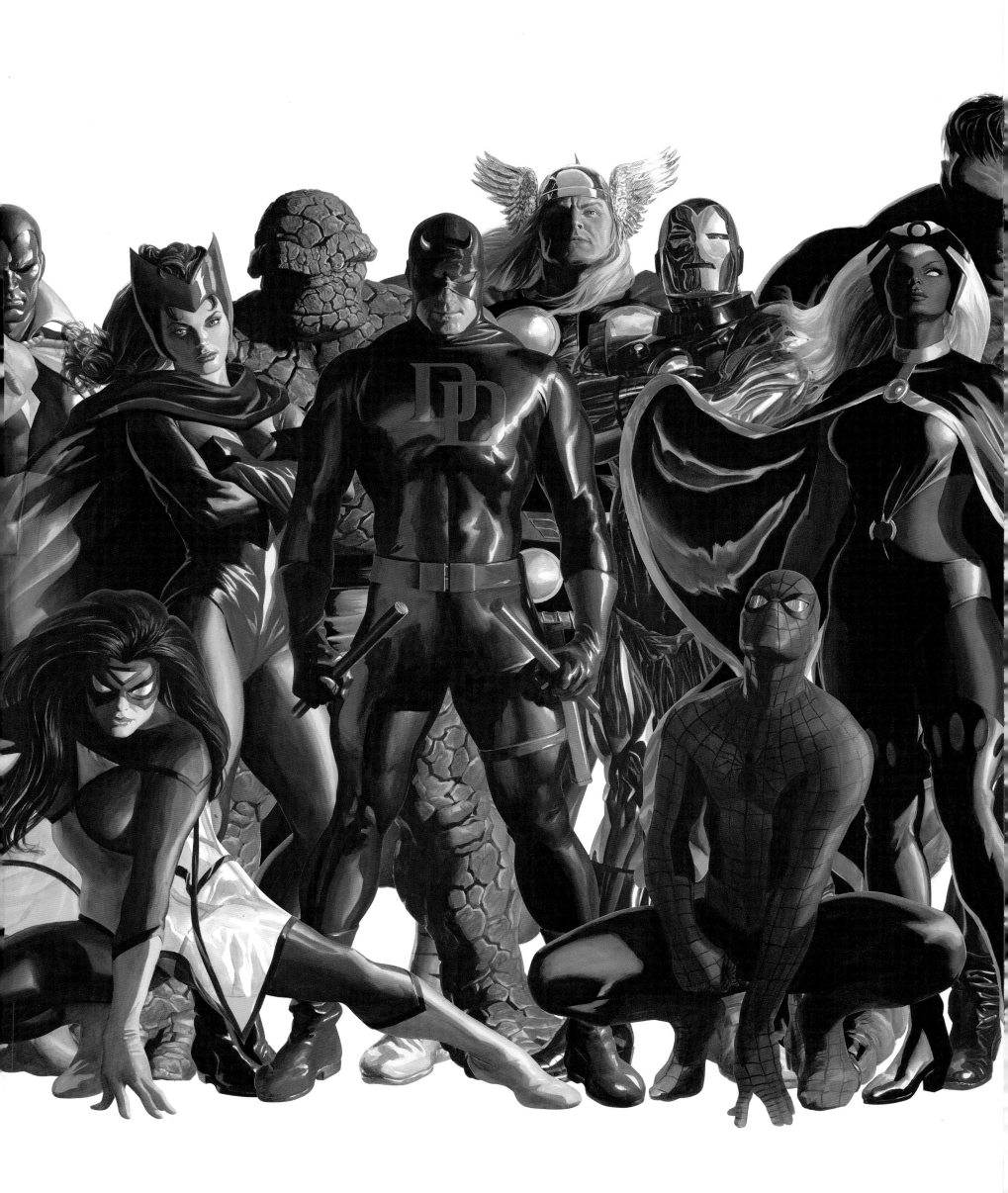

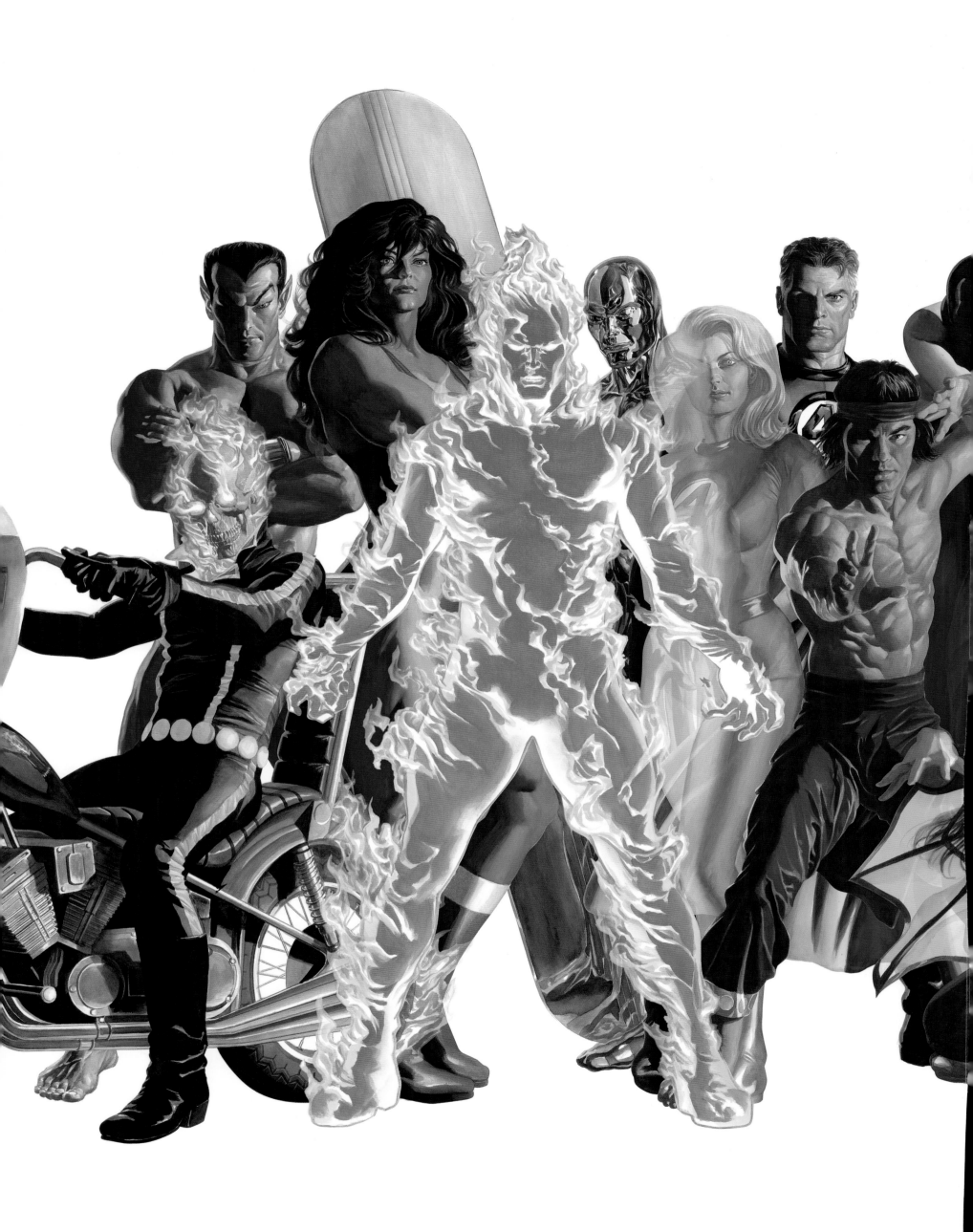